GUERRILLA MARKETING for ARTISTS

HOW YOU CAN BUILD A BULLETPROOF
ART CAREER WITH 100 COLLECTORS

Barney Davey

Bold Star Communications
SCOTTSDALE, AZ

Barney Davey / Bold Star Communications
PO Box 25386
Scottsdale, AZ 85255
www.barneydavey.com

Ordering Information:
Quantity sales. Special discounts are available on quantity pur-
chases by corporations, associations, and others. For details, con-
tact the "Special Sales Department" at the address above.

Guerrilla Marketing for Artists / Barney Davey —1st ed.
All rights reserved.
ISBN-13:978-1484048757
ISBN-10: 148404875X

Contents

To Mary

"Marketing is not an event, but a process... It has a beginning, a middle, but never an end, for it is a process. You improve it, perfect it, change it, even pause it. But you never stop it completely."

—JAY CONRAD LEVINSON

Foreword

The idea for this book originated from my workshops on art marketing for visual artists and photographers. As the past few years of a struggling economy have taken their toll on artists' businesses, it became apparent artists needed to do things differently if they were going to have a thriving, rewarding career.

I believe guerrilla-marketing techniques are the best way for artists to seize control of their careers. What worked in the past does not work as well now. At the same time, artists have more and better tools than ever to help them sell directly to their customers, and in a happy coincidence, collectors are more motivated to buy directly from them.

This is the second book to come from an art-marketing workshop. In 2005, I wrote *How to Profit from the Art Print Market*. I am proud to announce the second edition remains a bestseller on the Amazon.com "Business of Art" and "Prints" categories more than eight years later. That book came from my first art-marketing workshop, which I did for the Sedona Arts Center. (I owe a shout out and nod to Vince Fazio, the

Center's education director. Without his early encouragement, you might not be reading this book.] Afterwards, it quickly became apparent a book with the same information would help me reach many more artists than I ever could through doing workshops.

As soon as the book was published, I also began publishing an art business blog to help my readers stay current on changes in the art business with an emphasis on how art marketing was evolving. I picked a good time because between 2005, and now, the changes have been nothing less than seismic. Back then, a website was something to consider for advanced techie artists, but not essential for most artists. Galleries and publishers were still in control of much of the distribution of fine art. Since then, websites have become a necessity for artists, and other extraordinary developments have entered the market.

Those things include vastly improved consumer buying habits. We spend billions more for online purchases than we did in 2005. Print-on-demand technology in books and art prints has forever changed the landscape on how to get a book or print to market. Now, authors, musicians and artists can affordably publish their own work without having to carry inventory. Furthermore, they can use all sorts of sophisticated digital marketing tools to help them promote their work. The rise and phenomenon of blogging makes it easy for artists to build a loyal following of fans that they can talk to and market to directly. Website building has become easier with WordPress for the DIY crowd. Many superb specialized websites for artists are available for those who do not want to create their own website.

Websites and blogs began sweeping changes. Now social media, YouTube, email marketing, mobile marketing and more help artists reach new buyers. While all these different methods of building an art career and getting art sold have evolved, my business's one-line mission statement has remained constant:

Inform and inspire artists to build thriving careers through continued success at the business of art.

My goal is to present my followers, or tribe, to use today's tech vernacular, with the most effective methods to market art, whether old school or cutting edge. To communicate my ideas and findings, I use my books, blogs, newsletters, social media posts, and workshops. This book is in some ways the culmination of all those things. What I want for artists who read it is to come away with a guerrilla marketing plan they can follow to help them build their own tribe. I contend if visual artists can get 100 or more collectors who directly buy from him; it will solidify their art career. That loyal base will help him achieve his art career goals.

Visual artists are no different from other small business operators. They need affordable ways to find customers and drive sales. This is where marketing comes into the art career. Without effective use of it, there will be no sales and no successful art career. In the past, some artists could sell to galleries or publishers and then use their marketing muscle to advance their career. While that might be possible in some rare cases these days, the truth is most visual artists need to be self-reliant and carry their own water when it comes to getting their art to market.

Unless the artist is lucky enough to have deep financial resources, the odds are that time is more abundant than money. This book is for those artists who realize they must take control of their future by creating their own distribution channels and selling directly whenever possible. I chose Guerrilla Marketing for Artists for the title because it aptly describes the situation of most artists. That is, they need affordable innovative marketing strategies where they can invest their time, energy, and creativity without a backbreaking budget. Guerrilla marketing includes the belief that building a core of 100 collectors is best served by maintaining a base of existing collectors while consistently marketing to acquire new ones. I think blending an appropriate mix of traditional marketing methods, including direct mail, publicity, press releases, networking, referrals and advertising with digital tools such as websites, blogs, email marketing and social media is how visual artists can create an art career with them in control.

In the past, I have written about creative borrowing, and as such would be remiss if I failed to give credit to two men who have helped shape my marketing ideas. They are Jay Conrad Levinson and Perry Marshall. Levinson wrote his bestselling original *Guerrilla Marketing Handbook* in 1984 and has had sales of more than 21 million copies since then. He also has written or co-written dozens of other bestselling books on guerrilla marketing topics for various specialized situations and businesses. Perry Marshall is the author of *The Ultimate Guide to Google Adwords*. He is a renowned internet-marketing guru. His "Guerrilla Marketing for Hi-Tech Sales People" CD is a powerhouse of practical information and has been listened to by tens of thousands of his tribe. This book's title is in homage to Marshall's story of how he decided to use guerrilla marketing when naming his CD. In addition, to Levinson's enormous influence that has shown millions of small businesses how to level the playing field by using his perceptive marketing advice.

If you come away with a clearer understanding of what you need to do and how to make your art career flourish, then I will have succeeded

.

What Is Art Marketing?

Marketing is a systematized process of creating awareness and interest for a company, product or service that leads consumers to own its products and use its services. Businesses use marketing to communicate their offerings, promote their brands, identify new prospects, and strengthen bonds with existing customers.

Marketing can be complex and sophisticated requiring a lot of knowledge and education as evidenced by the fact that the largest companies seeking people with advanced degrees for entry-level marketing positions. Fortunately, to be successful marketing your art, an MBA in marketing is not necessary. By reading this book, you will learn how to use successful guerrilla art marketing techniques.

More than an MBA, you need a desire to be successful. To get there, you must be able to reach out of your comfort zone; apply relatively straightforward marketing tools; and use organizational skills to execute marketing plans, with the guerrilla marketing tools and techniques outlined here. On the business side, your art career success is about identifying your goals, your strengths, and the best marketing methods to use, and then diligently, routinely applying them to achieve your goals.

Reading this book will introduce you to numerous marketing concepts and programs. None of them is overly complicated to use nor expensive to employ. Varied art marketing methods

are unveiled and discussed in this book. The average artist will not have the ability to use them all at once, at least in the beginning.

On a More Sophisticated Level

This book is about how to succeed as an artist, which is all about developing a systematic process of getting your art seen and sold. The truth about art, or any product for that matter, is that unless people are aware of it, no one will buy it. Imagine if Apple created the iPad but failed to let anyone know it was available. They would have a near-revolutionary product with no sales. To thrive, you have to sell art, and to do that, you have to get your work seen.

A frequent frustration visual artists deal with is the knowledge that their art will sell well if only it could be seen by enough people. Family members of a deceased artist looking to help sell the artist's work posthumously have approached me several times. Unfortunately, this is the wrong time to try to promote an artist's work. The artist is gone, and there is no indication of future pieces. Galleries, dealers, and collectors are highly unlikely to want to take a chance on an unknown dead artist. If your work is vital, you need to give it the respect of properly marketing it as part of the process of having a fulfilling art career and legacy.

What Is Guerrilla Art Marketing?

Guerrilla marketing is a term coined by Jay Conrad Levinson in his 1984 book, Guerrilla Advertising. Inspired by the idea of how guerrilla warfare, which was so different from conventional warfare, Conrad led the charge to invent new, unconventional ways to gain attention for his clients' products.

Conrad understood that guerrilla marketing was so effective because it used irregular forms of warfare by implementing smart, small tactic strategies. For them, these often were the only method available for armed civilians to fight as insurgents against larger forces.

Guerrilla Marketing for Artists Builds Bulletproof Careers

What Conrad conceived realized about advertising is the same for your art career. That is, as an art marketer, you can use being passionate about your mission to wisely leverage your resources only on prized targets, and to focus your energy on winnable, decisive battles. As a guerrilla art marketer, you will gain control of your art career by strategically using affordable, available tools.

Guerrillas never fight wars. Instead, they focus on winning one small tactical victory after another. Your career will flourish as you become stronger, more capable, agile and powerful as you string victories together.

Your ultimate success is when the enthusiasm and support of your growing base of fans and friends elevate your art career to the point where it will thrive in any economy.

Guerrilla art marketing is about working smarter, not harder.

By following the advice in this book, you will learn to strategize about the events and actions that are truly necessary, and that offer the greatest return on your focused efforts. Your goal as a guerrilla art marketer is to gain market share, sell more art, add more collectors, and surpass your competitors without added expense to your marketing budget.

By carefully picking your battles, or art marketing targets, you will avoid marketing actions that are tempting, but produce poor results. Doing this always keeps you in the best position to win at the marketing activities when you do decide to engage.

An Art Career without Marketing Is Just a Pleasant Hobby – Barney Davey

There are innumerable living artists who are creating compelling artwork, but it is not selling for the simple reason that potential buyers do not see it. As mentioned previously, marketing creates awareness. Interest grows out of that awareness.

AIDA is a well-known acronym in the business world. It stands for:

- Attention
- Interest
- Desire
- Action

AIDA is a continuum that happens anytime a buying transaction takes place. Whether it is an impulse buy in a jewelry store or a prolonged decision to buy a piece of original art, the process remains the same.

ATTENTION

Imagine you are walking through a mall with the intention to buy some shoes. As you pass a jewelry store, one of the display cases attracts your attention. There in the display case you see a necklace. You had glanced at in the morning paper, and at that moment did not give it more than a glimmer of serious thought. Without your realization at the time, the ad had turned your **Attention** toward the necklace.

INTEREST

Now the display creates the effect of moving your awareness of the necklace to the next step on the continuum: interest. You hesitate for a few moments while gazing at the necklace. Impulsively, you march into the store and start searching to find that piece of jewelry to get a better look at it.

You find the piece just at the same time a salesperson arrives to ask if she can show you something. You point to the necklace and ask to see it. She pulls it from the case, places it on a velvet display pad, and proceeds to describe its many features. It is set in 10K white gold with an 18-inch rope chain and spring ring clasp. The beautiful heart-shaped ruby is lab-created, which allows for its perfection and affordable price. At this point, your **Interest** is piqued.

DESIRE

The salesperson asks if you would like to try on the necklace. Without hesitation, you say "yes," and before you know it, you are admiring the stunning find in a mirror supplied by the salesperson. Now, you have moved along the AIDA continuum to **Desire**. You want to own the piece. You only need to consider the cost, whether you can afford it, and if you should pay cash or charge it.

Marketing does these things. It grabs a potential buyer's attention for your art, helps drive interest in your work, and ultimately stimulates the desire to possess it. The necklace sale happened in a day. The sale might have occurred spontaneously even though you had not seen the ad in the morning paper, but it sure helped that you did see it. Conversely, you might have balked at buying at that time, but seeing the store's ads, emails and displays may have kept the impulse for you to buy later.

ACTION

Marketing is not selling. Sales take place only after enough attention; interest and desire are in play. I do not need to tell you that you cannot build a career on spontaneous art sales. Most art, especially originals, requires repeat exposure to your prospective buyers before attention, interest and desire can lead to **Action**, or in this case, the purchase.

Fine art sales usually require both partners in a relationship to decide on a purchase. Art is not as personal as jewelry. Since it is destined for display in the customer's home or office and is priced at a level requiring a partner-approved price, often both parties in the relationship must agree before the purchase is final. You need a marketing plan to identify your best prospects and put messages in front of them.

Back at the jewelry store, your helpful salesperson also facilitated the sale. Without her skillful presentation, noting the piece would look fabulous with your hair up, with a casual blouse and blue jeans or accessorize a perfect dress for a night

on the town, your decision to buy the piece might have dissipated.

She provided all the design details of the piece, explained the store's return policy, and offered to open a revolving charge or layaway as options to a direct purchase. In other words, she made you feel comfortable that you were making a fair, no-risk buying decision. More importantly, she helped you feel happy about your decision. You left the store convinced that you would be perfectly happy to own and wear the piece.

Without the advertising that caught your attention, the display case in the store window that aroused your interest, and the sales pitch that solidified your desire, you would never have made the purchase. The same is true of your art. If you are not frequently communicating to your best prospective customers that your art is for sale, and new pieces are available regularly, they are not going to buy from you.

Marketing Is Not Selling

Your salesperson in the store was a seasoned professional. She knew how to present the necklace to you and describe it in just the right way. She asked you questions and took a personal interest in you. She gave you suggestions on different ways you could wear the necklace. When it came to buying the piece, she gave you a choice of cash or credit. She noticed your slight uncertainty, offered to open a line of credit for you, and mentioned the store's layaway plan.

These are all sales actions, the last part of the AIDA selling continuum. True, you might have seen the same ad online and made the purchase without the aid of a salesperson. However, the interaction with the salesperson was the surest way for that jeweler to get that necklace in your hands and make you a satisfied customer. Regardless of how the transaction took place, it was the jeweler's marketing that first brought the necklace to your attention. The same is true when it comes to selling your art. You need to find ways to inform your customers and prospects to the fact that your work is available for them to get. You may sell your artwork online, and in this book,

you will be encouraged to do so. You should also be selling your art in person. As such, it is tremendously helpful to know how to sell art, or to have someone on your staff who can sell it for you.

I realize selling is not an easy task for many artists. Jason Horejs, my good friend and fellow art marketer, understands how it is for artists, too. Jason owns Xanadu Gallery, which is located on prestigious Main Street in Scottsdale, Arizona. He has sold millions of dollars in art during his nearly 20 years in the gallery business. His book, *How to Sell Art,* contains the most helpful info I have found on how to sell art in a face-to-face setting. You can find details on how to order *How to Sell Art* in the Resources section at the back of this book. In addition to covering face-to-face selling, this book also includes details on the best practices in online art sales. Although there is a different mindset and approach to selling art online versus face-to-face, you will find there are many similarities. As with art marketing in general, you also will find that using cohesive, coordinated systems will simplify your processes and deliver greater results, too.

Selling Art Is a Negotiation

It is not the intent of this book to give in-depth, systematic details on how to sell art. That said, the Resources section includes links to my e-book, *The Zen of Selling Art.* It compiles numerous blog posts and magazine articles I have written on how to sell art. Besides improving your sales skills, I strongly encourage you to improve your sales skills as well as to learn basic negotiation skills. At least, you should take the time to read *Getting to Yes,* or any of the many helpful books on negotiation.

Nearly everything you do in your art career involves negotiation. You negotiate art prices with buyers. You work out deals with galleries or for exhibit space and position. If you have a studio or retail space, you negotiate your rent. You may haggle over the price with a giclée printer or for art materials. You always will negotiate with your children, spouse or business

partner. Negotiations are an ongoing and intricate part of your daily life. Learning to negotiate is not learning to take advantage of another person. Negotiation is a skill that will help you get what you want from a deal without taking too much from the other person. If you are able through negotiation to do just five percent better returns on your dealings over the course of your career, it will add tens of thousands of dollars to your bottom line.

Art Marketing Matters

Many artists hold the mistaken belief that marketing their work somehow devalues it. The opinion that creativity and quality cannot exist simultaneously with financial success is widespread beyond the art community. It hinders the success of many small businesses. Even when there is a benevolent attitude toward marketing, the fear of or ambivalence toward performing necessary tasks such as marketing often holds business owners back.

This book will guide you toward the tools best suited to your resources and capabilities. You will receive detailed instructions on how to apply those tools to achieve the best returns. The purpose of writing this book and the point of you reading this book is the same. That is to propel you to new career heights without adding enormous expense by using the most powerful concepts, tools and techniques available to visual artists. The guerrilla marketing aspects of the book mean you will learn ways to use marketing so that every marketing ploy you use gets maximum benefit from it.

Art Career Goals, Dreams & Visions

If you don't know where you are going, any road will get you there. – Lewis Carroll

If you want to live a happy life, tie it to a goal, not to people or things. – Albert Einstein

We all dream. But not equally. To make your dreams possible, act on them with open eyes. – Robert D. Smith

Art marketing serves to help artists meet career goals and to sell more of their work. Art marketing is pointless without a goal. If an artist flits from Facebook to email marketing and from consumer advertising to seeking gallery representation without goals and plans to achieve them, that artist has wasted resources, which can cause career failure.

Setting career goals is critical to your success as a visual artist. They are an essential part of the process. Your goals form the touchstone for all decisions regarding your career. What are your art career goals? If you cannot state what your goals are right now, you are not alone. Just know it is never too late to start setting goals. If you take your career seriously and want others to take it seriously as well, you need clearly definable goals.

Simply stated, to succeed as a visual artist and a creative entrepreneur, you must have definite goals and a direction for your art career. These goals should be realistic and prioritized

with workable plans for achieving them. Otherwise, you are engaging in a pleasant pastime, not an art career.

"Goals" is used here to describe the key objectives a person wants to achieve related to his career and to earn an income. A word that transcends career goals is vision, or perhaps dream. Goals are targets to meet by performing a series of tasks to achieve a means to an end. Visions and dreams go beyond mere career goals. They delve into overarching aspirations that influence life roles in profound ways.

Visions and dreams are expressions of our deepest desires to be fulfilled beyond material and financial success. Career goals help you assess your career as it progresses. They help you be accountable to yourself for your commitment to complete your aims, to achieve your dreams.

The most self-fulfilled artists are not necessarily the ones who earn the most fame and fortune. They are the ones whose efforts have helped them realize their dreams. Although, for simplicity sake, we will use goals throughout this book, please understand the suggested exercises and ultimate aims are for you to come to that place where your dreams and vision become your reality.

One Ambitious Artist's Goals

I know a visual artist whose ultimate career goal is for her sculpture to become part of the permanent collection of the Museum of Modern Art (MoMA) in Manhattan. That singular, idealistic goal drives every career choice she makes and guides everything she does in her professional life.

This artist often has turned down opportunities to exhibit at shows, or to have certain galleries represent her because she feels doing so might lessen her more significant goal of getting into MoMA. Many other artists would have leaped at some of the offers she has declined. Others would have accepted them because their need for income was greater than their desire for acceptance in the highest circles of the art world.

Career goals and personal conditions do not always mesh. You may find yourself making sacrifices to your highest goals

in order to meet other obligations. That is the reality for most of us. Blind ambition can come at a cost. Having it all at once is impractical for those with families to support or other commitments. Accepting your situation and learning to deal with it comes with growing a thriving art business.

One need only study the careers of the most successful artists in any area of the arts to find the common intertwined themes of sacrifice and selfishness. Their sacrifice entails giving themselves 100 percent to advancing their career goals, which costs them the comforts and security of a more typical 9-to-5 gig. The selfishness is manifested in the knowledge that they may be unable to meet all the needs in the lives of their families and loved ones and their willingness to accept this.

Someone once said, you can have it all, but not all at once. This is no truer than in the price some artists pay to achieve their lofty goals. Life is full of tradeoffs. Your personal situation is unique. You may be free and unencumbered to pursue your passion, but more likely, you have commitments to others that will curb your ambitions and ability to fulfill your objectives as fast as you would like. The good news is that if you are reasonable and patient, you can achieve your art career goals.

When setting goals, you must consider such critical factors as your need for immediate income. If your goals are not feasible, then they certainly are not achievable. Not everyone has the resources to make a living while simultaneously holding onto the genuine, yet nonetheless farfetched, intention of getting their art into a prestigious gallery or museum. Does the artist mentioned earlier have other goals? Of course, she does, but in one way or the other, they all feed toward her primary goal. These additional goals include:

- Steadily increasing sales and value of her artwork
- Obtaining representation in top galleries internationally
- Achieving the respect of her peers, art critics and art collectors, both for the value of her work and for her unique artistic vision
- Networking to have her art owned by collectors whose tastes influence museum art buying trends

Those are highly aspirational goals for any artist. To be fair, they may be impractical for many, if not most, artists. Anyone can say they want their work exhibited in MoMA, or the Metropolitan Museum of Art, the Whitney, or other elite showplaces, but few have all the necessary ingredients to achieve such a goal. Your definition of success might be quite different from that of my sculptor friend. That is the way it should be. Success, like creativity in art, is unique to the artist.

What is Success?

Each person who pursues a dream experiences living on parallel reality tracks. The obvious track is the one on which we run our daily lives; the other is the engine for our aspirations. Most of us need both to get by, to make sense of our lives.

Sometimes the two tracks intersect in the most significant and productive ways. The stories that occur when this happens are the source that fuels the dream track. Often the vagaries of everyday life widen the distance between the two tracks. For many of us, a difficult economy can turn the gap from a minor rut to a major chasm. The chasm is so real for some that they reflect on and may even question the plausibility of their ability to pursue a successful career in the arts.

Pursuing a career as an artist is a daunting task under the best circumstances. Sure, there are the storied, fortunate few who apparently do not pay their dues, but somehow find themselves catapulted to stardom at an astounding rate. Such success is what we all hope for and dream about, but expecting it to materialize is akin to buying lottery tickets as a retirement plan. Since the astronomical odds of winning the lottery are almost the same whether or not you buy a ticket, it is unwise to count on hitting the jackpot as your sole means of funding your retirement. Likewise, the best way to have a reasonable opportunity to meet your art career goals is through effective guerrilla art marketing and not dreaming about magical events transforming our lives.

Defining success is an intensely personal thing. Only you can accurately determine what it is and what it means to you. Certainly, society has its markers, notably fame, fortune and such. I say success is being happy in achieving what one sets out to do. Nothing more, nothing less. If you are happy with the results of your chosen endeavors, then you are blessed and successful by my standards, and I bet by those people whose opinions matter to you.

Learning to Assess and Evaluate Your Art Career Goals Is a Process

Being able to honestly, accurately assess the value and quality of what you do is a gift. It comes easier to some artists than to others. However, if you have a few years' experience creating art, you should have a reasonable take on where your work fits in the art world.

In my bestselling (Amazon.com "Business of Art" & "Prints" categories) book, *How to Profit from the Art Print Market, 2nd Edition,* I devote a chapter to Goals and Vision. In it, I challenge my readers to ask themselves what they want to achieve from their art career. I believe that, from a marketing art and sales perspective, there are only three choices of career path:

1. Full-time artist
2. Part-time artist
3. Hobbyist

There is no right or wrong choice. It is simply a personal decision; artists must decide what makes the most sense for them. Hobbyists can paint or make whatever they want whenever they want. They are pursuing personal goals and vision while leaving the business aspects of an art career to others. For artists who aspire to full-time careers, or serious part-time careers, it is necessary to have clear goals and workable plans to execute around those goals, which must include positive cash flow from art sales.

Goals Are Essential Building Blocks to Success

Solid goals build thriving art careers. They form the basis for an art business and act as a guiding light to help artists make the best choices and to keep their art careers moving forward. Things change in our lives and our businesses because such goals are fungible, that is they need to be exchanged or replaced as needed to keep an art career on track.

It is easier to create goals that you can achieve within a period. For instance, setting five-year, one-year and quarterly goals will make sufficient planning for each period feasible. It is possible you will find that your goals are better suited to longer or shorter periods, such as a 10-year goal, or monthly, even weekly goals. Here is a S.M.A.R.T five-step plan to help you create realistic goals for your art career:

- Determine Your Goals. Take the time to figure out what is valuable to you and your family. Use the Goldilocks theory and make them neither too hard nor too easy, but just right for your situation.
- Prioritize Your Goals. Your priorities will determine what is most important and what is doable now versus what is doable as a future goal.
- Create a S.M.A.R.T Action Plan. SMART is a well-known goal-setting acronym.

S=Specific
M=Measurable
A=Attainable
R=Realistic
T=Timely

Revisit and Assess Your Goals and Actions.

Commit to a date. Set time aside and establish a routine to review your goals and your success in achieving them. In time, you will know if you are on track or if you need to revise your plans to align with the reality of your situation. Maybe you

have had a breakthrough, or maybe you have had a setback. That's life. Just learn to adapt and keep moving forward.

Share Your Success.

Share your success with others. Share it with yourself. When you reach a milestone, let others know you have reached your target. Take the time to enjoy your accomplishment. Find the time to share your success with others. Show them how you got there, or share your goal planning techniques so they can emulate what you have done.

The Power of Intention

Dr. Wayne Dyer has written books, created DVD lectures, and appeared on PBS television stations talking about the power of intention. He makes a strong case for how intention as energy becomes a force in the universe that allows the act of creation to take place. His *Wishes Fulfilled* book, DVD and PBS program, are poignant and powerful. I highly recommend them.

Another way to look at intention is through goal setting. Let's say you have determined a five-year career goal is to exhibit your work in 20 galleries, and sell your art to 500 people. I think of these things (the energy and goals), as being inextricably intertwined. That is, you simultaneously unleash your intentions and energy to focus on achievable goals.

If you need more help with goal setting, I suggest getting to know Chris Guillebeau. His bestselling book, *The Art of Non-Conformity: Set Your Own Rules, Live the Life You Want, and Change the World,* offers some of the best tips and suggestions for setting goals. You can read his blog at www.ChrisGuillebeau.com.

For many artists, the goal of 20 galleries and 500 buyers in five years may be too ambitious. Reaching such a goal involves an intense effort. Just considering the work involved in producing 500 original pieces of art in five years is not for everyone. Once you have actually judged your capabilities and resources,

you can set career goals that are both believable and achievable.

Wishful Thinking versus Wishful Actions

It is particularly beneficial to avoid creating unrealistic goals. Doing so is a prescription for failure. When you realize the goal is unattainable, it is human nature to take the foot off the pedal, to pull back and possibly fall into a funk. Just intently believing something will happen without backing up that belief with plans based on realistic expectations is merely wishful thinking.

Having a positive attitude is essential, but attitude alone will not garner you the success you desire. You need to couple your positive attitude with systematic actions aimed at furthering your career. Success comes when you successfully align your attitude with plausible plans and consistent actions designed to achieve your goals.

Guerrilla marketing is all about putting yourself in a situation where you are steadily creating art that has buyer appeal, and at the same time executing an effective marketing plan tailored to your ability and resources. By combining these powerful factors, you give yourself the best chance to enjoy a successful art career.

Prioritizing and Discipline Are Keys to Art Marketing Success

Practice career triage. The medical field widely uses the term *triage* to mean prioritizing who is treated, especially in battle conditions. However, it is also used in assigning priorities to projects based on available funds and other resources, in other words, determining what will most likely help you achieve success. Like making art, marketing art requires disciplined, regular and consistent actions by the artist or a trusted marketing person.

Growing awareness for and making sales of your work is the goal. As you learn to prioritize your marketing efforts, you will

discover how to accomplish more in less time. Ultimately, prioritizing makes decision making easier. In time, it also can generate extra hours for creating art and other profitable activities. Making the best choices and resolutely acting upon them is necessary to develop a successful art career. Capturing the attention of potential buyers requires a steady, orderly method of finding new ways to sell more art while retaining existing customers. These are the essential ingredients of a successful art career.

Being creative comes with blessings and curses. Visual artists are by nature curious. This helps them see the world through a different lens than other people. Having such a unique perspective also makes artists more sensitive to the world around them, and often is the author of their creativity, passion and enthusiasm for making art. These same traits also often are the cause of artists becoming distracted and undisciplined, especially when it comes to art marketing.

Unfocused creativity leads to confused marketing plans. By not prioritizing their marketing, artists can find themselves pulled in too many directions at once when trying to get their work to market. Many artists want to dabble in different art genres. They might be interested in working in diverse mediums, including watercolors, oil, pastels, or even sculpture or mixed media. Perhaps they also want to explore different genres such as landscapes, abstracts and portraits.

Entertaining imaginative impulses is helpful for a creative person; it keeps the stimuli at a high level. Regrettably, these impulses can be a trap for artists serious about marketing their work. Artists must concentrate on a distinctive style, or aesthetic. Consumers, art dealers, and art galleries rely on this continuity to help them understand artists and their work.

Know the difference between can and should. Not only can artists distract themselves, but they also are easy targets for others who want to use them or collaborate with them on a project. Do not succumb to the siren song of someone else's dream. Most grandiose plans brought to you by others are not going to work out. Like energy vampires, these people can drain you dry by distracting you from your goals, leading you

astray, and may end up costing you valuable time and effort that you cannot get back.

Use the touchstones that are your goals to guide you when career triage is necessary. Working on someone else's vision can turn into a disaster, especially if you have little input into how things are done. I am not advocating that you avoid all partnerships and shared opportunities, but instead I'm encouraging you to examine them carefully and think them through to all possible outcomes, good and bad. Most of the time, the upside is not worth it for you to take your mind off your primary goals.

Be disciplined. Stay focused and be wary of any offers that come your way. The best way to ensure your success is to make it on your own terms. When you fully control your career, your time, how and what you make, and how it gets to market, you probably will not have time for someone else's idea. More importantly, by staying the course, you remain at the helm, steering your career toward YOUR goals.

Think Big – Have a Grand Vision

Although keeping it real for art marketing purposes is necessary, you must also seek to push the envelope, to go beyond what you are doing now. It is healthy to want to dream big for your career. There is no dichotomy between dreaming big and keeping it real as long as you are not deluding yourself with your dreams. Do not be trapped by small thinking. Avoid limiting yourself in these three areas:

1. How you make your art
2. How you market your art
3. How you see your art business

Thinking small can be just as damaging a career trap as thinking too big. Your dream has to go beyond what you are doing now. It has to go beyond what you think you can do next year. It must be something you want and can visualize. It is nearly impossible to grow beyond your expectations.

On the other hand, be wary of thinking too big. When you go to that outer edge of your career path planning, it is wise to

find a mentor or coach who can help you avoid the pitfalls of reaching beyond your potential. Tap such resources to help you take your believable, achievable grand vision and turn it into step-by-step actions and goals.

Master Plan

For the most consistent results, learn to clarify your goals. No one can do it all at once. A master plan works by identifying core interests and routinely acting upon them in the simplest possible ways. Start by defining your life goals. Your career goals are sure to be a vital part of your life goals.

Create a list of everything you want to do with your life. Write it all down on a single sheet of paper. It can be your Bucket List if you will. It can include becoming a millionaire, having your art collected by renowned institutions and well-known collectors, traveling to Antarctica, writing a book, making a meaningful difference in the work of your favorite charity. Give yourself enough uninterrupted time so that you don't stop until you are finished.

Narrow your list to your top 10 choices. Take your time. You may want to come back to the list over the course of a few days, As you have time to think things through, your list will likely change. Take a break from working on your list. When you come back, a few hours or days later, whittle it down to your top four choices. That is about all anyone can reasonably handle at one time.

The result is a list of top priorities for your life. You should feel proud of achieving this as most people are unsure about their career goals. If that is too much to handle now, then just get a grip on your career goals. Much of what you learn in this book will help you achieve them.

Once you have your goals in mind, take time to visualize them or create a vision board for them. Then you can begin to make plans to achieve them.

1. Create a five-year plan to reach your number one goal. List the broad steps you will need to achieve this goal.

2. Create a one-year plan to achieve your number one goal. Make another list of steps you will need to take to move closer to this goal.
3. Repeat steps one and two to develop a plan for each of the other goals you want to accomplish.

Using a To-Do List

If you want to meet your goals, you have to break down the steps required to get there. Using a to-do list is the best way I have found to do this. You can use paper, index cards, or an app on your phone. The main thing is to learn how to consult and then use your to-do list to get things done.

I find the free Todoist.com service to be perfect for my needs. You can use it on your smartphone, and integrate it with Chrome, Firefox and/or Outlook. As with any tool, it only works when you use it well and make it part of your daily routine. Mind mapping tools can be extraordinarily helpful with goal setting and to-do lists. We will cover getting the most from mind mapping tools in a later chapter.

Getting Things Done

To-do lists help relieve your mind of anxiety about coming tasks, which allows you to concentrate on essential and urgent tasks at hand. David Allen's book, *Getting Things: The Art of Stress-Free Productivity,* provides clear advice that works. It is the reason it has been the number one bestseller on Amazon.com's "Time Management" category for ten years— because his advice works! His system is easy to absorb and begins to pay dividends immediately.

I would be remiss if I failed to mention one last bestselling business classic. It is *The E-Myth Revisited: Why Most Small Businesses Don't Work and What to Do About It* by Michael Gerber. In this book, the author helps you dispel common assumptions about running a small business. Allowing Gerber's advice to shed light on what you should be doing and what you should be delegating can be a career game changer for you.

Whether you have worked at it steadily or not, in one way or another, you have spent a lifetime preparing for a career as a successful artist. You did not acquire the tools and techniques you have in a few days or weeks. You are continuing to expand your talents and your career.

In this chapter, you found ideas and resources to help you first set and then begin to work on your career goals and set the stage for employing a successful guerrilla marketing strategy. Although you may be eager to get started, it is advisable to take your time to work out the best career goals you can. Sure, you will make course corrections along the way. However, having a clear, easily understood and communicated strategy is the best way to most effectively and efficiently progress toward your goals.

CHAPTER THREE

Assessing Your Resources

Let's start with your professional reputation. As an artist, who are you, and what is your reputation? You instinctively know your reputation is a priceless asset.

Reputation and visibility go hand in glove. Without an awareness of you and your work, there can be no reputation. It is true that curators, elite gallerists, art critics, pundits, and journalists are essential in building high-level contemporary art reputations based on their observations and recommenda-

tions. Nevertheless, for the majority of artists, a well-regarded and highly visible online reputation is their greatest asset.

The importance of search engine optimization (SEO) is indisputable for artists, and virtually all businesses, large and small, for growing their Internet presence. Most companies are attempting to gain higher search engine page rankings with their SEO activities. For artists, however, SEO can be more useful in gaining visibility and building a reputation than for making direct sales to unconnected, anonymous buyers. SEO is covered in more detail in Chapter Nine.

What is your current online visibility? Would a Google search for your name find you as an artist? Searching just by name is very broad, and if you have a common name, you most likely will not rank highly on a name-only search. What if the search was more granular and included your name, your city, region, or county? Would your name come up then? Would your name appear if the search also included the type of art you create?

If you cannot find your name when you make a long tail search, such as "Barney Davey, oil painter, Phoenix," you have not made a dent on the Internet. Nevertheless, do not worry: you can change this. As you implement the guerrilla marketing strategies found throughout this book that provide suggestions to help you grow your online presence, you will be planting the SEO seeds that steadily will improve your search results.

Do you have a local reputation for your art? Are you known in certain art circles for your art? Do people in your community, state or region know whom you as an artist? If so, why? Think about how that happened. If they don't know you, there are many actions you can take to remedy that situation. A full discussion of how to succeed in your local market in addressed in Chapter Six.

Do influential people in the art industry in your area know your name and your work? Do people who work in the art field you specialize in know you? For example, suppose you create historical paintings; do the members of various historical societies, museums and organizations know you? The more people who know you or about you, the more powerful your network resources become, and the quicker you will reach the success

made possible by following the guerrilla marketing steps outlined here.

To date, how much marketing have you done? In your marketing, do you present yourself as a brand? That is, are the aspects of your business other than your artwork identifiable as yours? Are your advertising and marketing materials recognizable as yours? Do all your marketing efforts include a logo, color scheme and graphic elements recognizable as yours and yours alone?

There is no shame if your reputation is not what it could be; everyone starts somewhere. Whatever your current situation, it can be improved to your advantage. You should start thinking about it now, and begin to identify steps you can take to raise your visibility quotient and reputation. Much of what you learn in later chapters will help you get this done. If you find that this discussion about developing reputation and brand awareness for you and your art sounds like business talk, and it does not sit comfortably with you, that is understandable. Nevertheless, you have to learn to disregard these negative preconceptions and learn a new way of marketing yourself. Your career depends on it.

Commitment

How eager are you to achieve your goals? This is a gut-check question, and you are the only one who can answer it. Somewhere deep inside you, you know the answer, regardless of whether or not you have thought much about it. You can measure yourself against other people you know who are successful. Are you doing the same things they are doing? Are you spending as much time on creating and marketing your art as they are? Have you routinely taken yourself out of your comfort zone, so you are getting things done that no one else will do for you, and that are vital to your business success?

The more you are willing to push yourself, and keep your commitments to yourself regarding your goals, the more you will succeed. This is not to say that if you are a little hesitant, or perhaps, not as committed as another person, you will not suc-

ceed. You can have success, but you will realize it on a less fast-paced track than others who are more fully committed to what they are doing. It may not just be a lack of commitment; circumstances often interfere with the best-laid plans. Life gets in the way of progress. Whether it is working a full-time job or a similar roadblock, you have to do your best to overcome these obstacles and keep them from slowing you down on your way to a successful art career.

There is more to success than commitment. There are time constraints. There are exactly 168 hours in each seven-day week; nobody gets any more or any less. How much time do you have to make your art, and how much time do you have to market it?

What do you do with your 168 hours? I have a practical resource for creating an hour-by-hour weekly spreadsheet. With it, you can see how you are using your time. The source for this spreadsheet is bestselling author Michael Hyatt. In a blog post titled How to Get More Margin in Your Life, (http://michaelhyatt.com/more-margin.html), he provides his Ideal Week. You can use his spreadsheet as a guideline to preparing your own Ideal Week. You may be surprised at the results of this exercise. You will learn where you are wasting time and where there are opportunities for you to make better use of your time.

In my opinion, the only way to make sure a diet works is if you track what you are eating. If you don't know what you are eating, you have no control over what's going in your body, and whether you are cutting enough calories to reduce your weight. The same is true with time: if you do not know what you are doing with your time, you will not be able to find ways to make better use of every hour in a day. There is almost no one I know who could not make use of an extra hour or more each day for something important. Doing so might result in your losing an hour of sleep at night, or you might learn to do things quicker, or bundle projects or shopping trips so you can find more free time.

Your time is precious to your career. As you learn how to implement guerrilla marketing to get your work to market, you will find that you are probably spending less time on marketing

activities than you were in the past. Working this correctly offers you potentially more free time to use in the studio, or other beneficial activities. To begin, start with an assessment. How much time do you allocate to creating your art, and how much time do you devote to marketing it? If you do not allow sufficient time for these two primary activities, it is going to be difficult for you to get to where you want to go and to meet your career goals at your desired pace. Along with commitment, you need to be honest with yourself regarding your self-discipline. Commitment and self-discipline work together. They contribute equally to your success.

You intuitively know if you are motivated to succeed in your career. My nephew is currently in residency as an emergency medical physician. He is one of the most self-disciplined people I know. As a child, he never had to be told to do his homework. Not surprisingly, he became valedictorian of his 700+ high school graduating class. He went on to become a Collegiate All-American soccer player. As an all-star athlete, he always gave his everything for his team, for his coach, and for his training. Despite the crazy schedule, he managed to live a normal social life, too.

This young man works diligently at everything. I admire him tremendously for his determination and commitment. For him, I believe it came more naturally than for others, including myself. I do not just look at my weekly calendar for inspiration and motivation. I look at a multi-year calendar. It spurs me to know I have to get things done today to begin to accomplish longer-range goals for things I desperately want to do and have not yet started. I am looking at what I can do in the next 10 years, and I know what I do or not do today will change that outcome.

Sometimes it is not lack of self-discipline, but lack of cohesive plans that prevent people from confidently working on the most important projects first. Maybe you are working on a commission, or building a collection of pieces for a show right now, but you genuinely want to be working on that next project that is exciting and potentially lucrative. This is where planning helps. If you have analyzed the steps you need to take to complete your current projects, you will finish them

quicker and with less stress. You will then be able to embark on that enticing future project sooner.

I find my goals drive me to the point where I am able to use them to enforce my self-discipline. For some, engaging a career coach is a worthy idea. It is a personal choice. Some artists will choose to not invest in a coach, but I have seen fantastic results from artists and others who use career coaches.

A skilled career coach will work to create a plan and then make sure you are sticking to it. A coach will hold you accountable in ways that maybe your spouse or someone else important in your life cannot or will not do. If you are lucky, you may have a spouse or a marketing partner who is willing and capable of filling this role. It must be someone who understands your level of self-discipline and who can help motivate you when you need a push in the right direction. If you have such a relationship, you are blessed.

Another option is to find an accountability partner. Find a colleague you know and trust who will help you keep to your commitments. Typically, accountability partners work in a reciprocal arrangement where you provide the same service to them.

Perhaps you have or could use a mentor. A coach will provide a business relationship, but a mentor is usually someone more experienced as an artist or businessperson who takes a personal and professional interest in you, and provides guidance to help motivate, inform and increase your business. A mentor will not typically help you with your discipline. This person may inspire you to stick to your plan, but will not likely have time to help you work on your self-discipline. If you lack self-discipline, and you know it, start looking for ways and getting help to improve. Routinely applying self-discipline is how you will get more things done, and secure your goals more quickly.

Organizational Skills

Organizational skills are most valuable. The more organized you are, the sooner you complete tasks. Highly motivated peo-

ple usually are also highly organized. They understand the importance of knowing what needs to get done now. They know the order in which they need to get things done, and they work diligently on accomplishing these tasks. High achievers use calendars, project manager software, contact books, to-do lists, mind maps, and other tools. Today, many of these tools are available as apps on your smartphone.

There are many productivity programs available. Most are software programs that will run on your smartphone, tablet or desktop. Some run on the old-fashioned index card systems. The point is to get organized so you can get more things done faster, and do the most crucial things first. The late Steven Covey, in his bestselling book, *Seven Habits of Highly Effective People*, sheds light on the importance of working on things that are both urgent and important. Too many of us, it seems, get trapped into working on things that are urgent, but not important. Except in rare cases, phone calls or email notifications are examples of urgent, but not important, distractions.

Combining organizational skills and techniques with self-discipline will help you in every aspect of your business and your life. When you can organize by urgent and important, and have a way to track and prioritize tasks, you are achieving what Covey noted as, "Keeping the main thing the main thing." When you learn to put first things first, you are on your way to greater success.

Financial

You cannot effectively market without money. Successful marketing requires more than time and effort; it requires sufficient funds. As such, you must assess your financial assets. Do you currently have a positive cash flow from your art business? Do you have an income from another source to use in your art business? The amount of funds required will vary depending on your goals and your personal situation. Marketing your art requires capital expenditure. You cannot find customers without investing to reach and influence them.

Marketing art need not be a drag on your other finances. You will find the suggestions in this book do not require a serious financial commitment. You can grow into your marketing if that is what your circumstances require. By assessing what you have to put into your marketing, you will get a clearer understanding of your current and future plans. In other words, your marketing can and should be scalable to your business plans and budget.

If you have a solid business plan, and are confident your work will sell when enough good prospects see it, then you can consider borrowing for your marketing plan. Sources include a home equity loan from your bank or credit union, a loan from a family member, or borrowing from someone who believes in you.

There are numerous micro-funding, or micro-lending, operations. An attractive one for artists is www.kickstarter.com. It is set up specifically to fund creative businesses that require relatively small amounts of money, such as $5,000 to $50,000 for startup or expansion costs. If you create a business plan that makes sense, consider using kickstarter.com. Alternatively, present that same business plan to family or friends, and you may find some willing investors for your business. As with time, the more money you have, the faster you can achieve your goals.

Personnel

Do you have a staff or are you operating as a solo entrepreneur? As you grow, you will require staff. It is something you should be thinking about now, even if it is a long-range plan. If you are lucky, you might have a family member or close friend or colleague who can help you staff your business. It can be the ideal situation when you have someone close to you who you can depend on, and who believes in you. With luck, they have marketing skills to help you to help grow your business, and have adequate time to devote to your fledgling enterprise.

One way or another, you cannot do it all on your own. You are going to need help. An excellent option for many artists is

to hire a virtual assistant (VA). There is an entire field of virtual assistants who specialize in helping small businesses. They come from all around the globe. A Google search for "virtual assistant" will generate a substantial number of options, including freelance sites such as odesk.com, elance.com, and guru.com. You can find them locally in any metro area.

VA services are available to help you with a variety of tasks, including some you might not expect. The don't just build websites or perform clerical work or transcription. A VA can write business plans or design graphics for you. Others specialize in social media marketing, and some do sales, marketing and research. They can do just about anything but create your art for you.

You should explore using a VA as an option, and if you are thinking, "I cannot afford it," then you seriously should rethink. Maybe it is not in your budget today, but if you have confidence in your art and your business plan, then you need to expand your vision of what your business can become. Start imagining how successful your business could be, how far your art will reach, and how much help you will need to fulfill your vision. Even a truly small business run by a solo artist can use a VA to handle tasks that are time-consuming and tedious. A VA can probably do tasks faster and quicker than you, which would leave you more time to make your art.

How good are your marketing skills? How much experience do you have? Not everyone has the same set of marketing skills. Do you understand basic marketing principles? Do you have an understanding of available tools and techniques, and how to use them? If you do, that is a terrific gift. If you do not, you will learn much profitable marketing information just by reading this book, and should be looking to outsource those things at which you do not excel, or disdain doing.

Besides this book, which lays out an excellent start for any artist, there is an incredible amount of rich information available on the Internet. Unfortunately, the Internet does not organize information particularly well. You have to be willing to do the research to find it. Alternatively, you might know someone, or can hire someone, who has business experience and marketing skills to contribute to your business. Business experi-

ence, preferably in marketing and sales, is what I recommend you look for as you plan to staff your art business.

Technology Expertise

Assessing your tech skills is necessary. Knowing how to create and manage your website and blog can save you money, but it will cost you time. Depending on your skill level, going the do-it-yourself model may not yield the best results. DIY versus hiring professional help: the choice is yours. In the beginning, carefully consider what is best for your individual situation.

Before you make decisions, work on evaluating your level of skill and your interest in technology. You may know how to handle these tasks, but lack the passion for it. It does not matter whether you are a hand coder who can build a website using html, css or php or you just want to login to add a new picture or write a new blog post. You must honestly appraise your tech skills and interests. Knowing your strengths, weaknesses and interests are invaluable to implementing a successful guerrilla marketing strategy.

With technology's increasing availability to small business, you need to know how to allocate and budget your time and money to make sure you stay competitive and are able to capitalize on the marketing opportunities available using digital tools. Having a clear understanding of what you can do and what you need help with will help you prepare your plans without wasting time.

Artistic Resources

This final section is about artists' resource assessment. What kind of art do you make? How long does it take you to make it? The quicker you create it, the more pieces you can get into the marketplace. Generating higher production rates yields more selling opportunities.

What are your price points? What is the average price of the art you sell? What is your markup on each item you sell? Are

your margins high enough to balance your overhead so that your business is profitable? Does your margin allow you to work with galleries, and possibly have an art rep commission included? How fast does your art sell? If you are painting one piece a month and only selling one piece a month, you have a problematic earning potential unless your price point is quite high.

What are your costs of goods, excluding your time? To know how much you will net from each piece you make, you need to know what it costs to make each piece. For instance, as a painter, what are the costs of the framing, canvas and art materials? How long does it take to complete each artwork?

As you gather the answers to the previous questions, you will begin to evaluate your earning potential. You will begin to understand your strengths as well as what skills need improvement to help you grow your business. You may need to create more work, raise your rates, turn over your inventory faster, to get a better return on investment from your efforts.

Conducting a candid evaluation of your skills and resources is the only way you can make plans that make sense. It is not enough to have one-year, two-year and five-year goals. By taking your time to understand your personal situation and circumstances, you will give yourself the best chance to set realistic, achievable goals. No two artists reading this book will have the same results.

I believe a thorough assessment as described in this chapter will empower you to shed misbeliefs about where you are and where you can go. I think most talented artists can do exceptional things, but not all can achieve their goals at the same speed. Once you match your resources and talents to suitable goals and develop a systematic plan of action, you will begin to see your career move forward on a continuous ascending trajectory. Planning for and using guerrilla-marketing methods to progress on your path is the basis of the rest of this book.

CHAPTER FOUR

Making Work That Sells

There is an ongoing, and perhaps never to be entirely decided, debate in the art community about the difference between making art that sells versus making art that you love to make. In an ideal world, these two things overlap each other completely, and if you are lucky, it might happen for you.

If not, consider overlapping a circle of the work you like to create with work that sells. In the middle, where the circles intersect, is a sweet spot. If you can create and sell art in that sweet spot all the time, you will be successful—assuming you do the other essential things to expose your work to the right kind of buyers. Getting this accomplished is tricky because you can neither always decide in advance what will sell nor completely control your creativity. Nevertheless, there are countless examples of artists who are able to work in a genre or style that is readily identifiable with them, that sells well, and that they love to make. While this is your ideal situation, it may not be your reality. Regardless, if you develop a style with marketable appeal that appeals to you as well, you are on your way to creating the success you envision.

The late Thomas Kinkade is an example of someone who worked hard at continuing to create a line of imagery that has proven to sell well. Although some within the art industry reviled him, mostly for the commercialization of his work, he was a dedicated, disciplined painter who worked eight hours a day at the easel when in his studio. He turned out an unusually

large body of work. Without question, he sold more prints than any other artist did.

In addition to his achievements creating art with mass appeal and selling it, Kinkade added large numbers of non-typical buyers to the idea of collecting art. As these buyers became more comfortable in a gallery, some moved on to become collectors of other artists' work. They might never have become art collectors if not initially introduced to the art world by Thomas Kinkade.

Despite his success as a painter of nostalgia, Kinkade desired recognition beyond that genre. His "plein air" style paintings never sold nearly as well as his cottage-themed or romantic-themed art, but in the opinion of many, including me, it was his better work. Although it seemed obvious he wanted success for his open-air style, he never gave up on the romantic cottage genre that built his business. He simply found the time for another creative outlet without abandoning the look he was famous for creating.

Robert Bateman is a national treasure in Canada. He has raised perhaps millions of dollars for conservation groups by donating his services and paintings. His wildlife paintings are exquisite in composition and detail; they invoke deep feeling and passion from viewers. Although he did not turn away from his teaching job until he was almost 50 years old, he built a fantastic reputation and body of work. You can find elements of still life, marine life, seascapes and mysticism in his work. Making work this varied, but remaining faithful to the genre, has benefitted him, his collectors, his galleries and his publisher. In studying Bateman's work, it is hard to imagine him plagued by boredom as he took on so many challenges with his art.

Terry Redlin is one of the most famous painters of Americana art. He retired in 2007, but interest in his work remains high. In his home state of South Dakota, there is a museum devoted to him. It remains a huge tourist attraction for people all over the globe. Fans come to visit, see and buy his art. Like Bateman, Redlin was able to mine an evocative range of imagery. He tapped deep into the psyche of his collectors. His images were of places most of us would love to visit. He made viewers

imagine being a young child on a breezy, colorful day, flying a kite, or wetting a line at a favorite fishing hole. To my eye upon seeing his work, I found it difficult to believe Redlin could ever tire of creating such popular works of art.

Posterity versus Prosperity

For a number of years, I was a guest blogger for AbsoluteArts.com. It is one of the premier worldwide online art vendors. One of my most popular articles on it is "Posterity versus Prosperity." The hypothesis attacked the starving artist syndrome. There is an unrelenting sentiment that making money from making art robs one of the purity of making art for art's sake. Those who think this way seem to think it is not possible to create art that is aesthetically pleasing, if not perfect while also making art that has commercial value. They assign such thoughts to the silly notion of "selling out."

It seems this ludicrous thought pattern only affects visual artists. There is no backlash against filmmakers, musicians, authors or playwrights for creating enormously successful work. Perhaps we should blame Vincent van Gogh. Sure, suffering for one's art can cause deep anguish that results in expressive art; however, it is not the only way to make fabulous art. I believe well-fed artists can muster creativity and interpret feelings and hardships without having to live through them.

In my "Posterity versus Prosperity" guest post, I wrote about an artist named Yuroz. He has made millions of dollars painting in a style influenced by Pablo Picasso. Because of his success at venues such at ArtExpo New York, where he sold expensive originals, but mostly limited edition giclée reproductions of his work, many curators considered his work too commercial for museum collections. In the post, I referenced a voluminous 4,000-word article from the *L.A. Times Sunday Magazine*. It used Yuroz as an example of how artists could be talented, but have too much success commercially in the wrong venues and, which would result in never seeing their work shown in museums.

Yuroz had read both the magazine article and my post. He wrote to me to express his displeasure at what he saw as an unfair characterization. I replied it was not my opinion, but rather my observation that this was how the art world works in general. I further explained to him that I believed, then as now that artists can enjoy prosperity and still live on to have their work honored in posterity. It is my conviction that your work can be both profitable and long-lived if you do it right.

As it turns out, Yuroz eventually had the last word as he professionally thumbed his nose at the editors of the magazine articles and other detractors of his work. He went on to see his paintings hanging in numerous museums, including at the Vatican. Yuroz's experience proves you can have it both ways. You do not have to endure the scourge of art world pundits just because you achieve commercial success. I contend that commercially successful artists do a better job of creating art awareness in the buying public than those who do not. If you make brilliant art and nobody sees it, that means nobody is buying it either. In the case of unknown starving artists, they are neither helping stimulate the art community nor creating awareness for the development of and interest in visual arts.

It comes down to this: successful artists are those who are true to their personal values and create/market their art with integrity. If it is your mission to have your work collected by museums, there is nothing wrong with such a goal. If you believe enjoying too much commercial success will derail your artistic goal, then prepare to find a benefactor or other source of income to help you in your quest. The reality is that a large percentage of working artists today need to make their art pay. In my opinion, it is a noble goal and a proud accomplishment to support your family through the sale of your artwork.

Of course, you need to be satisfied with the work you produce. Working without passion is no way to build a successful art career. It takes time to build a career. Working at creating in production situations is how many famous artists got started. The list of well-known and beloved artists of the 20th century who first honed their skills as illustrators is lengthy and includes Andrew Wyeth, Norman Rockwell and Andy Warhol. Other artists today work for publishers or licensing companies

cranking out pieces on demand. There is no shame in doing this. If anything, the discipline to work steadily and fulfill others' visions of finished work is excellent preparation.

When you start your own art business, being exposed to outside influences will yield benefits. Learn to use your own interests to develop a consistent style. Long-term success comes from innovation, but also from style. It is important that your work is recognizable. It is commendable and beneficial for your art to be identifiable as yours, and yours alone.

There Are Riches in Niches

There are numerous examples of artists who have developed a loyal following and highly profitable business model around a niche market. The range of interests seems endless. Some examples include marine art, wildlife art, Americana, romantic cottages, naïve art, motorcycle art, dog art, wine art, and Aspen trees. The point is if you find a theme or topic that has enough appeal to potential buyers and to you as an artist, you can turn that passion into gold.

Ron Burns began painting dogs more than twenty years ago. His first muse was his own pet, Rufus, who was a shelter dog. That path led him to a career full of rewards and recognition. He began donating part of his sales to support the Humane Society. As a result, he became the first and only "Artist in Residence of The Humane Society of the United States."

Thomas Arvid is perhaps the most well-known painter of wine and wine-related subjects. He has made an impressive career selling realistic paintings related to wine. His oversized still life compositions of wine and the rituals surrounding it became a sensation. The look started a trend that many other artists have attempted to emulate as they sought entry into the world of art and wine connoisseurs. Arvid's work has been commissioned by leading wineries and represented in more than fifty galleries worldwide.

Scott Jacobs is another artist who specializes in realism. He climbed to success painting motorcycles, mostly from photographs taken at the annual Sturgis rally in South Dakota. He

would go to Sturgis to walk around and find potential subjects. His method was to take pictures of unique bikes and leave a note on a bike that read, "Please call me. I would like your permission to paint your bike." Who would have thought such a subject matter would become collectible? He went on to become the first artist officially licensed through Harley-Davidson's worldwide "Fine Art Program" in 1993.

The Chevrolet Motor Company (Corvette Division) has also licensed Jacobs's work. Other licensors of his work include Mattel; Hot Wheels Race Team working with Kyle Petty; the Marilyn Monroe Estate for its Marilyn Merlot wine; and Elvis Presley Enterprises, creating images for their wine label, Elvis Presley.

In 2012, Scott Jacobs appeared on the ABC television show "Secret Millionaire." The show located successful business people who are willing to go undercover for a whole week and work among people living in poverty. Jacobs ended his episode of the show by giving away hundreds of thousands of dollars to needy people and organizations he encountered. Through his art and his niche, he has become a multi-millionaire and internationally known artist. His success allows him to do extraordinary things with his money for his family and others.

Dave Chapple is an artist who carved out a successful career in the wildlife market. For more than a decade, with a single artist representative, he sold directly to Ducks Unlimited, other conservation groups, and hunters. Together, Chapple and his rep marketed his realistic paintings and etchings of ducks and other wildlife scenes. Although he was selling enough art to earn around $100,000 annually, and additionally paying his rep about half that much during that time, outside of his tiny niche, few in the art world knew him.

Chapple was not looking for the limelight. He loved making his type of art. He had found a niche that worked for him. Follow your passion for finding your own profitable niche. Start by making work that sells, and that you love to create. It is entirely possible only your niche will know you, and you will still enjoy a truly rewarding career.

Paul Brent paints whimsical, tropical beach scenes. He built a strong following marketing his self-published watercolors as posters. His publishing ventures led him into the licensing

business. Today he annually earns millions on his licensed images. His art has a distinct style. For those who want a depiction of a beach cottage or Caribbean-themed decor, his work fits perfectly. To their delight, lovers of his work can get his images on everything from shower curtains, wallpaper, floor mats, greeting cards and much more.

To some people, the idea of licensing one's work is distasteful. True, the decision about how you want to promote your art to the world, and how you might make money from doing so, is an intensely personal one. It is a big tent, which makes room for everybody. Whatever you choose for your career, I suggest not wasting your time debating or agonizing about what other artists are doing with theirs. Be true to yourself, and the rest will follow.

You need to decide whether you are going to follow a trend or start a trend. Both approaches have upsides and downsides. Worrying about being first in, or coming in later, is far less momentous than concentrating on making commercially viable art and building a massive fan and collector base that will buy it. I think you should do what is intriguing and inspiring to you.

If other artists influence your work, I see no harm in allowing that. If artists did not move in unison with their contemporaries, influential art movements would never evolve. If you wholly and directly copy another artist, that is poor practice. Surely, doing so is unethical, and possibly illegal. If you are influenced by the work of someone who is also painting in a particular thematic style, but using your own creativity to create a distinctive art statement, there is no harm in that.

Being aware of trends, and how to incorporate them, will help you sell more art. Seeking to set edgy trends is somewhat risky from a business perspective. If you already enjoy a following with a more traditional style of art, you might want to pursue marketing venues outside the ordinary. Learn to be versatile. If you have a creative outlook, time and capacity to follow your passion, and you are productive, consider selling some of your work under a different name. A *nom de brosse*, if you will.

I used to work for a Scottsdale, Arizona, gallery housed in a design center where it primarily catered to designers, but also was open to the public. We worked with a couple who painted Tuscany-style work and sold it under their real names. At the same time, they were in another gallery across town that displayed abstract work they made under different names.

Everybody knew what was going on; there was no attempt by the artists to hide what they were doing. It was perfectly acceptable to all parties. It was just a way for artists to make more money and express themselves in different ways without confusing their collectors. The artists did not care about becoming famous under their assumed names; they were painting to make a living and enjoy what they were doing. It was terrific for them, and for both galleries. If you have the desire and means to produce art in this way, go for it.

When it comes to making art that sells, one of the keys to success is creating it fast enough to keep the pipeline filled all the time. With production speed, you can aggressively market knowing you can fill orders as received. A chief component of success in producing art on schedule is knowing when to quit. Leonardo Da Vinci said art is never finished, just abandoned. The previously mentioned Michael Hyatt is a blogger I follow. He is a practical, pragmatic person who offers excellent advice on leadership, marketing and personal development. He says perfectionism is the father of procrastination. If you are a perfectionist and having a hard time completing art on a schedule, you might be hiding insecurities about getting your work into the marketplace. There is no shame in recognizing your underlying, unspoken motives. The shame comes when you accept that your perfectionism might be sabotaging your career, and you still fail to do anything about it.

You need to know when to quit, when good is good enough. Sure, you can endlessly tweak your art, but be honest: will your tiny tweaks make your art more desirable or saleable? No one knows when or why you stopped at a certain point. Learn to get over your fears and perfectionism or whatever else is causing your procrastination, then work on getting your work to market efficiently. Doing this is a superb career kick-starter.

When you think about making work that sells, consider creating reproductions for the print market. You have read here about Paul Brent, Terry Redlin, Robert Bateman, Thomas Kinkade and Thomas Arvid. They have many things in common, including that they all are tremendously successful in the print market. Marketing reproductions of their work means that their income multiplies. Instead of making one piece of work and earning one payment for it, they make one piece and receive payments many times over.

Marketing your work in the print market opens the doors to the licensing market, the home furnishings market, and the hospitality design market. These markets are your ticket to selling your art in hotels, resorts, office buildings, and healthcare facilities, including hospitals, medical centers, and doctors' offices. It is much easier to break into markets such as these when you have reproductions of your work available. Being in the print market opens many doors. The key to being successful in these markets is making work that sells. My *How to Profit from the Art Print Market*, 2nd Edition, and ArtPrintIssues.com blog are excellent resources for learning more about the print market.

Marketing You

When it comes to being successful as an artist, there is more to it than making work that is popular and sells well. "Marketing You" is a way of concisely talking about all the other elements of a successfully marketed art career. As a concept, marketing you is not about attempting to promote you, the artist, as a personality. Although it can be effective, that approach won't work for every artist. If you aren't the person who is intimidated by including your personality in your art and your marketing, it can be useful, but it is not necessary. Marketing you is about paying attention to everything that goes into creating a successful career for yourself.

The three pillars of marketing you as an artist are:

1. Visibility
2. Credibility
3. Profitability

VISIBILITY

Visibility encompasses all activities that raise awareness for you and your art. If you want to make work that people are more and more aware of, and sell at competitive market prices, you have to be visible. This includes participating in online activities such as blogs, websites, and comments and guest posts

on other blogs, reviews, online galleries and social media. Marketing your off-line self includes personal appearances and extends to your gallery and studio (if open to the public), shows, fairs, publicity items, press releases and more.

CREDIBILITY

Credibility starts with the quality of your work. This encompasses your creativity and imagination, how you interpret, describe and explain your art. It also includes the quality of the materials you use as well as the way you handle and ship your art.

Having visibility adds to your credibility. When your name and work precede you into a conversation or negotiation, they are an asset and helps elevate your credibility. Your actions also confirm your authentic self and your believability as an artist. When it is obvious to all that you are a person of high integrity, your credibility rises. Your integrity is part of everything you do. You cannot avoid it, so why not embrace it to advance your career?

How you appear drives your public persona, as does your reputation as both a person and artist. Beyond your manners, mannerisms and appearance are your achievements in life, education and the art market. Your associations also drive your credibility. All your affiliations with non-profit organizations, civic, industry, alumni, or other groups are in the mix. While connection with such groups does not affect your artistic talent and creativity, it is measurable and relevant to some of the buying public.

PROFITABILITY

At the convergence of visibility and credibility, you achieve profitability. Of course, how much money you make, and, more important, how much you save as profit, is not determined solely by how well you are known and how well you are regarded by others. Nevertheless, visibility and credibility are essential elements of your overall profitability. Without them, the success you desire is less likely achievable.

Making work that sells, as outlined in Chapter Four, is a vital ingredient to profitability. Having a consistent, effective marketing program goes arm in arm with making commercially viable art. Marketing drives awareness for the art you make, and helps develop interested buyers toward the decision to own your work. The remaining chapters of this book are about marketing your art.

Personal branding

The concept of "Marketing You" includes personal branding. Personal branding is a description of the processes whereby people and their careers are marked as brands. Personal branding is a concept first used by Napoleon Hill in 1937. He is the author of the seminal self-help book, *Think & Grow Rich*.

Another way to help you understand personal branding is in the answer to this question: "What do people say about you, how do they describe you, when they cannot think of your name?"

Personal branding helps artists stand out from their competitors and leverage the different ways they reach their audience. The three reasons for you to work at your personal brand are to be:

1. Definable
2. Understandable
3. Recognizable

As your art becomes more definable, promoting your work to first-time buyers becomes easier, and it increases the desire of past customers to continue to buy your art. Being definable does not mean being predictable. You could choose to have an unpredictable style, but that is not a plan I would encourage you to follow. Definable can include the type of art you do, the lifestyle you live, or other meaningful activities unrelated to your art career. As your fans and the world around you recognize you for things beyond your art, you create a definable personal branding style that is a valuable and powerful marketing asset.

Being understandable simply means your collectors "get it." Ordinary art buyers may not understand conceptual art. However, this might be the intention of some of these artists. Regardless, on some level, conceptual artists strive to make their work definable to their intended audience just as much as Monet's "Water Lilies" are easily comprehended to the average art buyer. A collector who buys into a piece of conceptual art does so because s/he "gets it." The clever jokes that characterized Andy Warhol's work were often lost on average art buyers, but critics and collectors loved them.

Being recognizable does not mean having paparazzi camped outside your door, or having strangers asking for autographs while you are at dinner. Leave that for celebrities, movie personalities, sports, and rock stars. As an artist, you want recognition for your work. One way to achieve cult status is with a big personality and the right kind of work. You may not define your success that way.

Michael Godard is an example of an artist who is instantly recognizable by anyone who collects his work. He shot to fame with his outsized personality and rock star looks. A lighthearted perspective of life personifies his work. It includes martinis with animated olives, drunken grapes, dancing strawberries, gambling and the good life. What else would you expect from someone who bills himself as the "Rock Star of the Art World"?

Jane Wooster Scott's art is instantly recognizable to those who collect her work. Her distinctive style has kept her a favorite of fans of primitive American folk art for decades. Although many of her most devoted collectors might recognize her in public, it is certain a large percentage would not. There is nothing wrong with being famous in your niche and still enjoying relative anonymity in public.

Martha Stewart is a perfect example and an expert at personal branding. Her brand is something she has taken to the extreme and to the bank. Another iconic personal brand is basketball star Michael Jordan. He knows the value of his personal brand and treats it with respect. For instance, although it was sometimes only a few yards from the hotel elevator to the team bus, he would never leave a hotel room without being immaculately dressed. He realized there would be fans that

might never see him again in public, and he wanted that one impression they had to be memorable.

Taking the time to do this is how he practiced his personal brand. He defined himself rather than letting others do it for him. Jordan's personal brand is beyond the standard of nearly any living artists, but there is much to be learned from watching the masters and analyzing their actions for use on your level. How you look when you are in the public is part of your personal brand.

Brand Identity

Creating a unified look for your identity will help you with your marketing and branding, which in turn will help you sell more art. Here are some of the essential brand identity items you need to consider.

You might wonder as an artist if you actually need a logo, corresponding graphics and consistent color themes. Think about how many different ways you cast your message out into the world. Here are some of the most popular ways you communicate your brand beyond your art:

- Logo
- Color scheme
- Graphic elements
- Business card
- Sell sheets
- Brochure
- Artist statement
- Stationery
- Postcard
- Gallery marketing kit
- Website
- Blog
- Facebook page
- Advertising
- Shipping label

If you think about it, it will not be difficult to add items to this list. Although it can be tempting to create your own logo, a better option is to hire or barter with a graphic designer. Having drawing skills and an exceptional eye for color does not constitute having the training in typography, graphic elements, object placement, and a whole host of other things. When a talented graphic designer creates a logo with the greatest care, it will elevate your brand. Besides, you may be too close to the subject to be able to produce the best graphic designs for yourself. Consider this a once-in-a-great-while, perhaps a lifetime, investment in improving your branding and messaging. Since these integrated elements will send thousands of visual branding messages for you over time, the cost for a professional design is minimal.

Of the various ways to get your marketing message across, business cards are the least useful. They are not in line with modern marketing techniques and, more important, they are an easy way for prospects to blow you off, or forget about you. Asking for a business card is a sincere and easy way to slide off the hook of commitment. Whenever possible, provide a business card only as a last resort. Instead, substitute a postcard or sales sheet with a call to action. Either way do not make the other person responsible for keeping the conversation going. Instead, ask if you can follow up and then suggest a time convenient for you. Then you must keep your promise by following up promptly. Always ask for permission to add the person to your postal and email lists, and then do it. Make it a habit to send an email, or a handwritten note on an art card that displays your work as a reminder of your appointment, and take the time to mention that their name is now on your lists.

Personal Branding

Within your art business, you should strive to develop a look and aura that is iconic and impressive. Use the ideas you learned here to begin to make this happen. Getting all this done will not happen overnight. However, if you steadily work at including ways to brand yourself and your work beyond your

art, you eventually will begin to see the payoffs in increased awareness and appreciation for your art and you.

The Coca-Cola bottle and Coke logo are among the most memorable brand icons and graphic elements. I can show you a Coke bottle shape, and in a flash, you will recognize the product. It is obvious you cannot compete with Coke's billions of dollars and decades in marketing, but the good news is that you don't have to. While you cannot match Coke's iconic status, you can learn invaluable lessons about how to present your art business to the world. Coke's branding proves there is power in presenting a cohesive look to your marketing and in how you communicate with your customers. These things are not enormous investments in time or money. They require thinking, deciding and acting on classic marketing practices that apply to individual artists as much as to global consumer brands.

Not all pieces of your marketing and branding program have to match so perfectly as to be boring, but having a unified look can help you promote the look of your work and make your marketing materials both eye-catching and professional. The easier you make it for someone to connect with you on a visual level, the most comfortable they become when making buying decisions about your art. If you remember that we defined branding as what others say to describe you when they can't recall your name, then you can translate that into understanding how the visual part of branding is just as valuable. For instance, if your fans recognize your logo or other graphic elements before they see anything else, your branding is doing its job.

On some level, you already know yourself pretty well. On other levels, you may not be as aware of how others perceive your values, personal mission, and unique attributes. Most of us do not think about these things on a daily basis; however, lack of perspective about them is a distinct disadvantage when you are marketing to others. Take the time to decide how and what you want to be known for and use that knowledge to find a niche for yourself and your work. Ask your friends and family to define who they think you are in one or two sentences. Alternatively, ask them what words they would use to describe

you. Incorporate the positive perceptions you get from others into your branding and marketing.

An unseen brand is not a brand. Marketing is all about you working to lift the proverbial bushel basket from the light of your brand. Work on improving effectiveness in communicating your brand by using as many of the tools mentioned in this book as possible. This includes online activities, in-person appearances, networking, publicity, press releases, media relations, visual branding, and more.

Work on maintaining the momentum you achieve with a consistent effort to expand your reach and influence your best prospects, and to fast track your career. Make it a practice to update and improve your brand. Start a Google Alert for your name to track how others are attempting to promote or otherwise define your career. Create other Google Alerts to track keywords that describe you, your art or your career. Developing this one habit can expand your arsenal of knowledge about the art world around you, and how others perceive you in it.

Why should you care about personal branding?

The answer is easy. If you fail to brand yourself, someone else will do it for you, and most likely the results will not be to your satisfaction. Gary Vaynerchuk is a social media evangelist and author of two *New York Times* bestselling books, *Crush It!: Why NOW Is the Time to Cash In on Your Passion* and *The Thank You Economy*. He adroitly puts it this way: "I don't care what business you're in, everybody today is in the branding and customer service business. Whether you know it or not, you already are."

Define who you are and leverage it

A case in point is Wyland, the marine artist who dropped his first name from everything associated with his art career. In the art world, he is Wyland. He is a brand on a rather grand scale for a living artist.

You may not be able to emulate Wyland and paint 100 whaling walls on buildings all around the globe, or have an image on a California license plate that directs donations to marine conservation groups. Nevertheless, that should not stop you from letting his branding techniques inspire and inform you. Start with what you have and work outward, remaining consistent with your message, your mission and your style. Ask yourself how you can use your art, and possibly your status, to change the world around you.

The saying, "Fake it until you make it" has some truth to it. If you do not learn to take giant steps that move you outside your comfort range and push you to achieve new things, it is extremely difficult to grow as an artist, and as a person. Faking it does not mean being a fake. You need to be truly authentic in what you do and how you present yourself. Faking it in this context simply means you are learning on the fly and sometimes only one step ahead of your audience and benefactors.

Be Authentic

Learn to let the real you come through; people can spot a phony a mile away. If you act the same in every situation, it is much easier to be authentic and genuine. These are immensely appealing attributes. If you are shy, or unsure about how you are perceived by others, take the time to evaluate your achievements, not just as an artist, but also as a person. Without dwelling on accomplishments, learn to accept yourself and be happy with whom you are. Your acceptance of yourself comes across in subtle ways to those around you. Being an authentic, approachable, sincere person makes you attractive in intangible, yet powerful, ways.

Being happy does not mean you are happy with all factors of your life or career. You still can be eager to improve both, and I hope you are. Be happy for what you are now, and for the promise of what you are in the process of becoming. When you do, you will find being comfortable in your own skin grows easier. Moreover, you will find yourself more captivating to your

fans, prospects and others who are increasingly intrigued by who you are.

Sometimes it takes sharing something about yourself to attract people toward your work. Art collectors want to know the whole you. This does not require you to share intimate secrets or victimize others with TMI (Too Much Information.) However, revealing some imperfections makes you more approachable, likable, real and unique. As a rule, people consider those who are both accomplished and genuine to be the kind of people who are most liked and admired. Finally, do not feel the need to be humble. Demonstrating that you believe in yourself, your art and your brand in an authentic, yet not bragging, style is compelling.

Stanford Business professor, Deborah Gruenfeld has a fascinating, informative YouTube video titled: *Power & Influence: The Body Language of Power.* (Link listed in the Resources section.) Gruenfeld talks about easy ways to learn how to use the power of body language to be authoritative, to be approachable and to be dynamic. As she explains it, you will find yourself nodding in agreement with how body language is used.

According to Gruenfeld, there are appropriate times to "play high" in order to fill the space around you and to be authoritative. But it is better in some cases to "play low" to allow you to show deference to someone whose assistance you need. Be aware of situations when you enter them. Keep your own agenda in mind, and you can consciously learn to use these techniques to accomplish your goals for the event or situation in which you find yourself. She offers powerful insights and suggestions that, with a little effort and practice, you can effectively use.

Sometimes simple things are the most memorable. John Chester is the co-founder of Wild Apple Graphics, in Woodstock, Vermont. He and his wife Laurie started their business better than twenty-five years ago. Today, they run one of the most successful and well-known art print poster and licensing businesses in the industry. (As an aside, I sold John his very first trade magazine ad space and tradeshow booth space when we were both rookies in the art market.) When you en-

counter John at a trade show, note his name badge, which displays the titles of both president and janitor. At one time, he was both. Today, the badge pays homage to his humble beginnings and to his quirky sense of humor. This is a terrific conversation starter, and makes him easy to approach. It also makes it stress-free for others to enjoy his company and feel at ease with him, instantly. It is part of his personal brand.

Besides being authentic, approachable and likable, showing proper respect for your collectors, fans and prospects are a crucial factor in building lasting relationships with them. Find unique ways to show your appreciation. Send notes and emails when they are not expected. If you know someone is interested in a subject, do a little research and send them a link, an article, or even a book about that interest. If you know something personal about them, whether favorable or something unpleasant that has happened, send a handwritten note to acknowledge you have them in your thoughts. Follow them on social media and use what you know to communicate with your customers on a level that is not a seller-to-buyer message.

Have you done business with a company and come away feeling like you just had an unexpectedly pleasant experience? When something like that happens to me, I am much more likely to send business their way. I also am much more likely to recommend the company without being prompted to do so. Besides being an active listener with your customers, use common social courtesies by offering appropriate "please," "thank you" and "my pleasure" responses as you communicate with them.

You can enhance the unique experience a step further by applying it to how you present your art, how you ship it and how you describe it. Uniqueness can be as uncomplicated as how you answer the phone. It might be the unanticipated pack of note cards tucked in the shipping container. Whatever you do, make sure it comes from your heart. Your customers are sure to know and appreciate your actions.

Personal Appearance

You read earlier about how Michael Jordan dresses sharp for a short trip across the hotel lobby to the team bus. He gets it, and you should take your cue from him. You do not have to dress to the nines every time you step out in public, but you should strive to portray yourself as polished and professional. That means being well groomed, hair coiffed or at least neatly combed, facial hair trimmed, clothes cleaned and pressed, shoes shined or at least not scuffed.

The socks-in-Birkenstocks appearance does not help to promote art. Neither does anything you do that makes you look like a shabby, carefree, casual, unkempt artist. It makes you look like you do not care about your appearance. Worse, it increases the likelihood that collectors will associate your personal grooming with your art and worry that you also might take less care in creating your art than you should. Bottom line: look your best. It is true that when you look good, you will feel right, and that translates into making you more confident, which translates into your gaining more confidence in yourself from your collectors.

Self-confidence

Self-confidence is sexy and alluring. The next time you are in a room with a bunch of people who are socializing take the time to observe the social dynamic. It is true that attractive people often create attention just because of their looks. Nonetheless, if you take note of what is going on, you will find those who, regardless of looks, exude a natural self-confidence often are the ones who garner the most attention. Whereas looks are superficial, confidence is substantial and influential.

Also, note that the opposite of self-confidence is cockiness, which is a most unattractive trait. There are examples of arrogant and pugnacious artists who succeed despite their obnoxious personalities. If that is your shtick and you can carry it off, bully for you. Exhibiting these traits usually are attempts to hide insecurities. You can try this path, but not with our rec-

ommendation. It is much better for you to work on getting rid of your insecurities than to attract attention by being boorish or a bully.

Although you may accept your insecurities, you do not need to reveal them either. We all feel uncomfortable in certain situations. This is not a personal self-help book, and as such, I cannot delve into the subject deeply. Besides, many useful books on the market help improve self-confidence. Perhaps the best is Susan Cain's bestseller, *Quiet: The Power of Introverts in a World That Can't Stop Talking.* If you need some help building your confidence, use the wisdom in her book and tap the plethora of other available resources.

Of course, you want to feel and be confident. Who doesn't? There is every chance you may start out feeling insecure. What do you do when this is the case? Most people have to work at developing confidence and assuredness. It is not something we just wish for, and it happens. It takes practice to realize you are a talented human being, worthy of respect and admiration.

Start by identifying your successes and strengths. Be grateful for your expertise and achievements. Do not be shy about being ambitious. Be positive in the face of adversity; you are what you think. Learn to be gracious when receiving compliments. Never deflect a compliment with a self-denigrating reply. Be genuinely grateful and joyful for the affirmation. Vow never again to spoil the moment by using self-deprecating comments as a weak attempt at humor to hide your embarrassment at being honored with a compliment. Try simply saying "Thank you" with your biggest, genuine, wide-eyed smile.

Speaking of smiles, practice yours in a mirror or webcam. When you smile, people smile back at you. It is a natural reflex. It works on you, too. Smiling more is physiological. It helps you maintain a sunnier outlook on life. Practice your smile. It works. This exercise will help improve your confidence. A smile is more than a turned-up mouth. A genuine smile comes from the eyes. If you smile from your eyes, your mouth is sure to follow. Smiling at someone this way when you greet them sends a message of warmth, openness and honesty. A wide-eyed smile

is evident, albeit almost intangible, but the person you are with will notice the difference even if s/he is not aware of it.

There is a theory of an alternate universe, or multiple alternative universes. In the law of vast numbers with potentially trillions of universes, statistically, your exact double, your Doppelgänger, exists somewhere. Whether you buy that or not, you can use the idea to help you appear confident when inside you are feeling insecure. Imagine your alternate self is a happy, self-confident being all the time. Let yourself be that person for a while. Just acting that way can help you stay that way. Some actors fall so deeply into a character while portraying them, they have a difficult time not being that other person. You do not have to go that deep to find other ways to perceive yourself positively and to act on the perceptions. There are countless numbers of performers and speakers who initially were scared half to death to go on stage or in front of the camera. With practice, they overcame their doubts and fears, and so can you.

There is power in being grateful, gracious and standing for something

Stick to your principles. It might be hard, but if you don't have something you can believe in, you don't have anything at all. If you don't stand for something, you will fall for anything. No matter what's happened in your life, you can always lay claim to the fact that, from this day forward, you have followed your principles to the best of your ability. Help others. Be kind to people around you and you will make a positive difference in their lives (even if it is just showing a bit of warmth to the person serving your coffee in the morning). Small acts of human kindness make you a positive force in the world. The side benefit to you is a continuing boost to your self-confidence.

Practice giving compliments to others. It is easy. If you already know something about the person, say it. If they are new to you, be observant. Find something pleasant to speak to them about—their appearance, or any other aspect you might see. What kind of car do they drive? What phone do they use?

Do they have a book, magazine or something else in their hands? If family or friends accompany them, mention them in some positive way. The more you practice giving compliments, the more it will become a standard part of your personality. Spread the cheer!

Confidence and giving off a personal aura of warmth and success are secret guerrilla marketing strengths. When all else is equal, people will buy and support people they like. It is human nature. Working at feeling good about yourself and projecting that to others makes you more attractive to them. The natural side benefit is that self-confidence radiates over all aspects of your life, and not just your art business. Start with an awareness of where you are now and commit to working at improving yourself in small incremental steps. The first step is in believing that you can exude self-confidence and the next steps are working towards making that happen. For some, just as with achieving anything worthwhile in life, this work will take longer. It is a process with continuous benefits to your whole life. As such, improving your self-confidence is precious to you on countless levels.

Self-promotion

Many people have the idea that it is unseemly to do any kind of self-promotion. Do not be one of them. If you harbor such notions, get rid of them. The brutal truth is that if you are unwilling to promote yourself and your art you cannot expect anyone else to do it for you. Leading by example is how you get others, especially those working for you, to promote you. No one is asking you to do stupid human tricks to be noticed. Nevertheless, just as you may need to practice raising your confidence level, you also may need to work on your self-promotion techniques.

Guerrilla marketing at its most fundamental level is you recognizing you have to toot your own horn, and then doing it. No matter how successful you are, or how talented you are, being a supporter of your own work is part of boosting your art career. Ask yourself why the biggest movie and recording stars

hit the road to promote their latest movie or album. You would think the A-listers could just put out a product and their fans would come running with cash in hand. The fact is that some actually will jump on to buy whatever is new from their idols, but those diehard fans do not represent a broad enough base to create a resounding success.

We will discuss many useful promotional and marketing tools in later chapters of this book. I must give you this story. In the mid-1990s, when ArtExpo New York was at its peak in terms of being "the place" for artists to showcase their work, I attended a post-show unveiling party for the artist Michel Delacroix. He is a highly successful contemporary painter in the "naif" style. The party took place at the swank Maxim's nightclub and lounge in Manhattan. It was a catered dinner event. Robin Leach, host of the television show, "Lifestyles of the Rich and Famous," and Ivana Trump were the guests of honor. They unveiled the new Delacroix original. It sold at the affair for $40,000.

I attended the party with a friend who is a sculptor. She was arguably the most accomplished artist in the room. What was most impressive about her that night was that she was also the most prepared artist in the room. Her small clutch purse carried postcards and business cards that were ready to hand out to the right people. She was careful not to spam everyone she met with her promotional materials. However, she was remarkably adept at nonchalantly gathering information about those to whom she was talking. When she encountered someone she felt she needed to know, she nimbly brought out her materials. She did not stop there, however; she took their card and made a point to set a follow-up meeting, either in person or by phone, where she could continue her conversation with that person.

She acted with class and dignity, and without being showy. I do not know if she made any high-caliber contacts that night that yielded any sales or other benefits, but I do know she gave herself the best chance of making that happen. This was not some fluke event. It is how she thinks ahead about what she does. She knew where she was going and planned for what she would do when she got there. She knows what she wants to do

with her career and in the moment where she finds herself. That is how I suggest you use self-promotion. That is, with class and dignity and in a way that you take full advantage of every situation you encounter.

Think about what you are doing and have a plan of attack for making something happen when you arrive. It might be there is nothing to gain or do, but if you are still prepared, you will give yourself many more opportunities to apply basic guerrilla marketing tactics to get your art seen and sold.

On Being Fearless

Fear is real; we all live with it. You can never fully remove a primary emotion like it from your life. Still, you can work on eliminating your fear of failure. This is a prime reason many otherwise talented artists fail to develop a successful career. They undermine their future by succumbing to fear. If you think there is something you could never do that might otherwise help your career, and do not take action, you 100 percent have proven your point and assured it to be true.

Fear causes us to throw up one objection after another about why we cannot do something. Unless you lack any self-awareness, there have to be situations you can remember where you let your fear of failure, or fear of rejection keep you from attempting something bold for your career. For example, if you think you could never win that contest or get into some exclusive show, it condemns you to making your thought a reality.

Fear and the inability to overcome it is a leading career killer. There is a saying, "The dread is worse than the do." It applies to art careers and omissions due to fear. If there are things you know you could do, but have never tried because fear is holding you back, you can learn to overcome those doubts and succeed. Does acting on our fears and moving forward with plans and actions despite our misgivings mean success is around the corner? Of course not, a nearly continuous meme goes around the Internet on how Abraham Lincoln, Einstein, Michael Jordan, Thomas Edison and other giants all had

experienced profound failures before they became successful. The point here is that each of them never let failure stop him from becoming successful. They all looked beyond their failures as they learned from them and moved on to greatness.

The easiest way to overcome fear of failure is to start by imagining the worst that can happen. It is a simple, yet powerful, way to overcome your worst fears. You can imagine miserable failure and examine it before you take action. Ask yourself what abject failure looks like. What does it feel like? What is the worst possible outcome? If you know what those things are, and they are short of death, dismemberment and utter financial ruin, then you can see that you could survive failure if it happened to you.

The next step is to imagine how you will recover. What actions can you take afterwards if the worst happens? There is always a path back; you have to see it and believe you can follow it when things do not turn out as you expect. They call it "Plan B" for a reason; it is true. Having an alternative in mind if your first choice doesn't turn out is how to steel yourself for the worst as you hope, plan, and strive for the best.

Push yourself to be great. Be unrelenting in becoming a better artist, a more efficient guerrilla marketer, and an enthusiastic proponent of your career. You will have no regrets if you do everything you can to better yourself as an artist and person. Furthermore, you will not have to live with the nagging "What if?" Give living your dream of being a successful artist your best shot. You may have to wait for the right time, but that should not stop you from planning for your illustrious career, free of fear of failure, full of confidence with the sales and acclaim you deserve.

Local Marketing

Local marketing is an essential part of guerrilla marketing. It is working at selling your art in the community where you live and do business. Local guerrilla art marketing is akin to grass roots marketing in politics, where elections are won by amassing votes one at a time. Building your career one collector at a time is the best way to solidify it.

Local marketing is one of the biggest trends in marketing both online and in person, over the last few years. Search engines have focused on making local marketing an integral part of the search experience. They know that search generally is either global or local. Social media, Groupon, smartphones, and traditional media all help fuel interest in local marketing.

The "Small Business Saturday" push to coincide with the "Black Friday" shopping frenzy on the day after the Thanksgiving holiday in the U.S. helped shape the year round trend towards local marketing. This trend emphasizing local marketing all year coincides with the pattern of shifting social trends identified by authors Roy H. Williams and Michael R. Drew in *Pendulum*, their new book. They theorize that society swings from a "Me" cycle to a "We" cycle every forty years. They have used thousands of years of history to figure out why we've acted the way we do. Their claim is the last "Me" cycle began in 1963 and ended in 2003. We have moved from focusing on individual freedom to emphasizing community, authenticity and transparency. It is a fascinating book for helping businesses,

large and small, understand and predict business and social trends. I believe the resurgence in local marketing and the rising interest in handmade goods as epitomized by the success of Etsy.com reflect the current Pendulum "We" cycle theory.

Artists' works often are indicators of shifts in society. For instance, some hypothesize that the Impressionist movement with its loose strokes was a non-conformist reply to the Industrial Age. If machines and factories could endlessly turn out exact replicas of whatever they were capable of making, then art could resist by making beauty that was anything but an exact imitation of nature. I cannot claim to predict the future, or that I can spot art trends associated with the current shift to a "We" cycle in the pendulum theory. I can, however, clearly see the trend and opportunity for artists to capitalize on it with a local marketing strategy.

An artist should be able to tap into the public's desire to shop locally and take advantage of the fact that people want to buy from those who live in the same area as they do. Artists are lucky because they can market locally, nationally, and globally. I am not suggesting that artists should try to do all three at once. Although it is possible, most artists do not have the ability, time, or resources to handle all three markets at once. This is especially true of artists just getting started with their marketing strategy.

Advantages and challenges of local marketing

What are some of the advantages of local marketing? Naturally you get to sell to people you know, or to someone who knows the people you know, and they get to buy from someone in their local community. It is a tremendous advantage when you're not marketing to complete strangers. Don't be shy about emphasizing in your marketing materials that customers who shop locally are helping to keep jobs related to their purchases in their local community.

Although doing business with those you know increases your chances of making a sale, the number of sales you can make locally depends on the size of your market. Small towns

may not be able to support a thriving art business. In addition, you may desire recognition on a national or international level, and marketing locally might not help you achieve that goal of national or international recognition. As stated previously, you can promote both locally and nationally or globally. It makes sense to focus on one area at a time, especially for artists in the early career stages. As such, it is a good idea for artists just starting out in business to focus on marketing locally. It is my opinion that many artists who are spending time trying to first market to consumers who live thousands of miles away from their home turf are missing what's often called the "low hanging fruit."

If you ignore the potential customer base in your own backyard while spending time and effort trying to develop a following far away from home, you have your marketing turned inside out. Your marketing should be concentric. This means picking a radius around your hometown to start your marketing. Depending on the size of your area, you could start drawing a 100-mile circle from where you live, then a 200-mile and 300-mile circle. Using the service at www.freemaptools.com makes this task easy to complete. By using guerrilla marketing tactics like this, you keep your marketing compact, which allows you an affordable way to focus on the prospects closest to home.

It makes sense to expand your customer base in a continuous process. The guerrilla marketing strategy is to start locally, and advance to regional, national and international markets. You can support each phase with targeted online marketing and advertising efforts, and carry over the success from one to the next. As with all the advice and suggestions in this book, this may not apply to your situation. In general, local marketing is the most affordable, and usually the easiest, way to launch your guerrilla marketing campaign.

Grow where you're planted

Building a base of business, a firm foundation around where you manage your studio, and possibly retail location, is a smart

idea. Set a goal of building a loyal, local and regional following of 100 collectors. It will not happen overnight; in most cases, it will take several years to achieve even 50 collectors. Artists who grasp that a core of 50-100 loyal buyers gives them a solid foundation for their business grow also gain the confidence to branch out and do other things including marketing nationally or globally, and extending their brand into other fields. .

Production capabilities are different for every artist. I once heard a rule of thumb that is feasible to me. It states that most full-time artists will paint about 1,000 originals in a lifetime. The math says if you make 30 pieces a year for 30 years you will have made 900 pieces. Only you know for sure what is likely for your career. With the 1,000 pieces in a career model theory, you can see that applying it to the 100-collector goal makes a nice dent in your total sales. Selling two or three pieces to each of those 100 is not farfetched. Moreover, neither is assuming that among those 100 collectors there are those influential types who could be responsible for introducing you to another 100 collectors over 30 years. Alternatively, perhaps their connections will positively affect your career in other untold ways.

When you promote locally and directly, you can build healthy relationships with your collectors, much more so than you are likely to create with sales in galleries and online. Building close relationships with your collectors fits in perfectly with the "We" cycle of the Pendulum Theory. Of course, you will find some of your most loyal collectors who become closest to you will come from those relationships. The idea here with guerrilla marketing is for you to establish a base of operations and a core group of collectors whose enthusiasm and purchases will feed your larger ambitions, no matter how large they may be. A few centers of influence can steer your career to the success you believe your art deserves. I have said before in some of my blog posts that I will take 100 direct buyers and personal relationships rather than 1,000 Facebook fans or 2,000 Twitter followers.

I contend that it is much easier to sell art to local businesses such as resorts, restaurants, and medical facilities, than to try to sell to similar companies in distant locations. In those places, where you are unknown, everything is more complicat-

ed and expensive because of shipping and travel involved. So how do you go about getting involved in local business opportunities for your art? See if looking at how to do it with this approach makes sense for you: you may have heard of the parlor game Six Degrees of Kevin Bacon. It is based on the "six degrees of separation" concept, which posits that two random people on Earth are, on average, about six acquaintances from each other. It rests on the assumption that any individual involved in the entertainment industry can be linked through his or her film roles to Kevin Bacon within six steps. Kevin Bacon may have worked with this person, who in turn worked with this person, who worked with that person, and so on until through only six people you have connected Kevin Bacon to another entertainer.

It is a remarkable idea. Microsoft reportedly did a study a few years ago to see how accurate six degrees of separation actually is. Its findings proved that one person is slightly less than six people away from any other person on the planet. You can use the concept of six degrees of separation in a marketing capacity. In fact, it can become one of the strongest planks in your guerrilla marketing strategy.

Look at the stats on how big your potential connections are on the LinkedIn site. You will see that by targeting the right relationships you can reach out to those in a position to affect your career positively.

Before you apply this concept, you need a plan. First, decide what you want to achieve from working the "six degrees of you" game. For instance, you may want to reach a local gallery owner; a director of cultural affairs; a museum curator or donor. Your need might be to meet a prominent publicist or art critic in your area who you know could help you if you could reach them with valid reasons why you wanted to engage them. First, identify your target with clear intentions on what you need. Then begin to work on how to achieve your goal. You start by asking people who you think are the best prospects for knowing someone who might know someone. When you ask, have a stated purpose in mind. In most cases, you also will want to ask how you can help the person whose support you

are trying to recruit. By offering mutual support, you are going to have greater results than by merely asking. In other words, by having a specific reason to talk to the person, you are going to have greater results than if, for example, you just wanted to meet them without an explicit reason.

Begin to think about how you can formulate a plan to incorporate six degrees of you to get to know the right people in your community that is, the people who can help you. I suggest you do some brainstorming. Perhaps you can find, or form, a mastermind group. Get other artists involved. This is where you can use an online group. Maybe you get help from others online; you might find them through LinkedIn.com. Maybe you meet them by participating in your local art community, through your organization or association. Gather a group of artists in a salon type of format, where you can talk about these things. What do you need to do with your career? How do you become more successful? Who do you need to know to help you become more successful? Start by tapping into your family and friends and their connections. These are your faithful support. Who do they know? Moreover, who is it those people know? By doing this, you move steps closer to being successful with six degrees of you.

As you go through this exercise, you are going to find that the people who will be useful to you typically fall into two categories. There are those who want to prove that they are powerful and connected. These people are truly delighted to show their power for you and reach out to the right people to help you. The other type of person is the do-gooder, who genuinely wants to help other people. It doesn't matter what their motivation is, as long as they are willing to help you. The best thing is that you get their commitment to help you achieve your goal of finding your target audience. Meeting the right one or two people can make an enormous impact on your career. You cannot leave it to chance that you get to meet the right people when there is a way for you to reach out to them through your local, warm market. Taking action in this way is a perfect example of guerrilla marketing at its best.

Important people to know

In his bestselling book, *The Tipping Point*, Malcolm Gladwell talks about two different types of people who can make strong impressions on society and are instrumental in creating a tipping point. What you are looking for is the tipping point in your career. You are going to involve as many of these people as you can find. As you start developing your local marketing plan, and then regional and national plans, think about these two types of people. The first group is composed of the mavens. Mavens are people who have a tremendous amount of knowledge or wisdom on a particular subject or on many different subjects. They are our "go-to" resources when we are looking for advice on a particular topic. Gladwell contends that corporations provide toll-free numbers on their products because they know mavens are the ones who call them.

Companies have developed this technique to a fine point. For example, they know an individual who calls about a particular product represents a certain percentage of their audience. By getting this valuable feedback, they are able to determine consumer perceptions regarding their products in the marketplace. They use this information to improve the products and their marketing. Mavens often are early adapters. They are likely to identify trends sooner than others, and they work in conjunction with another group that Gladwell calls connectors.

Connectors are the people in a group who know far more than the average number of people. Given a list of 500 family names, they might know 150 people with that last name versus the 20 people the average person knows. More important, connectors are in the routine habit of making introductions. Therefore, when you have both connectors and mavens in your social network, it will help you get closer to your goal of the right people noticing you work.

You may also get help from affinity groups such as the aforementioned Dave Chapple did from Ducks Unlimited. For example, if your art relates to fans of orchids, or volunteers at shelters for homeless animals, or are sports enthusiasts, you

will find groups of such like-minded people within your community. An affinity group is composed of individuals who can point you in the right direction and help you devise not only a way to get to other people, but maybe a means to clarify your marketing objectives. Affinity groups provide a distinct means for you to identify and befriend mavens and connectors. A word of caution is to engage such groups and organizations only if you share their passion. In our current "We" cycle, we are looking for authenticity and transparency. If you are just in it for the money, you probably will be found out, if not drummed out.

Career coaches can make a difference

I realize talking about career coaches is not a natural extension of local marketing, and that using one was mentioned earlier. I am going to include the importance of using a coach here because it makes just as much sense in this context as it would be in any other chapter.

For some artists having a business coach or a personal coach, is useful to propelling a career. A professional coach not only can help you define your goals in terms of moving forward with your career, but also will hold you accountable to achieve those goals. Coaches are an integral part of the careers of top Olympic athletes. They usually receive credit for being instrumental in helping to instill the discipline necessary for an athlete to achieve a goal. They do this in a variety of ways, including providing practical advice on sharpening skills or offering encouragement when times are tough. As an artist, you also can benefit from the insights and specialized knowledge of a talented coach.

As you begin a search for a coach, start with knowing where you need help. A good coach can provide a variety of services; some will be better-suited for particular aspects of your career. Do you need assistance with making sales presentations or working your "six degrees" plan? Some might be there for a specific purpose such as licensing.

The right coach can help you to develop an encompassing long-term development and marketing strategy for your art career. Keep track of your needs as you work through deciding what parts of your business require the most support. When you are satisfied with your decision, commit to finding the best coach for your art career.

The perfect solution would be to have someone who is both local and who has experience in art marketing. The fact is that may not be possible for your art business. Not meeting either of these criteria is a molehill, not a mountain. Don't worry because any experienced coach will have mastery over the necessary tools and strategies required by businesses of all types. The two most essential things you need from a coach are accurate assessment and honesty. Your family and friends are probably too biased in your favor or lack the critical skills to evaluate your work to provide you with useful feedback. A skilled coach will inspire you, steer you in the right direction and tell you when you are off track or not producing the quality or quantity of work needed to fulfill your plans. Look for a good fit. There has to be equal trust in a coaching relationship. You have to have confidence your coach actually gets what you are about and what your career goals are. You need someone who does more than dictate policy and procedure from a manual or from the prism of their own experience. In other words, s/he needs to be involved with your business in an intimate way and to show and explain that they know ways to help you improve it.

Now that you have determined that it is important that the coach is a good fit for you, you have to find the right one. Your local SCORE chapter is one place to look. SCORE is an acronym for Society of Retired Executives and is a part of the U.S. government Small Business Administration. If you have plans that involve seeking an SBA loan to secure those plans, a SCORE mentor will be an excellent start. Because there are no official licensing agencies for career coaches, your search will turn up a wide range of quality and skills among those laying claim to being a career expert or business coach. You can find numerous contacts for art business coaches by doing your own In-

ternet searches for "art business coach," or "art marketing coach." The main thing is to do your due diligence once you develop an interest in a particular coach. There are organizations and certifications for coaches. Searching for them may be helpful. Your best resource is other artists. Use your Facebook and social media contacts to broaden your search to find a good match for your needs.

Targeting art buyers

To increase your success, you need to know who buys your art. It's not necessarily a demographic, but often it can be defined in that way. Is your audience predominantly female, male, or both? Are they members of the Baby Boomer Generation (born before 1966); Generation X (born 1966-1976); Generation Y (born 1977-1994); or Generation Z (born 1995 to the present)? Who is buying your art locally? The better you know and understand the needs and desires of your target market, the easier it will be to sell to them.

Local marketing can also be considered concentric geographic marketing as touched upon earlier. As previously suggested, use freemaptools.com to pinpoint your location; then you can use it to draw a radius around 100, 250, 500 and 600 miles. Some of you will be surprised to learn how many large cities are within those concentric circles. Of course, every region is different. In Phoenix, for example, a 600-mile radius will take you to places in Texas, Nevada, and southern California. With tens of millions of people inside the radius, there are enough prospects to justify driving the distance to promote your art. It also takes you to a lot of empty deserts, Mexico and the Pacific Ocean.

Depending on the size of your local market, I suggest you concentrate at first on a smaller range, say a 100 to 150-mile radius. Most of us live within 100 to 150 miles of at least one or two large cities. Ask yourself how many art galleries you know. Do you know how many frame shops are located within your concentric circles? Have you made efforts to contact those gallery and frame shop owners in your area? How many people do

you know in neighboring cities? What do you know about the demographics of those cities? What goes on there? What goes on there that ties into the kind of art that you're making? What kinds of museums are in your circles, and how many are around your area? The more you know about your local environment and its surroundings, the more you can notice sales and marketing opportunities.

Begin to think about your potential opportunities and how your art might fill a need in the lives of the people living in your target geographic market, and then work on making your art fit those needs. Are there new developments or new housing tracks going up? Are there new office buildings being built? Are there new doctors' offices, medical facilities or hospitals? These are all opportunities for you to sell your art locally or regionally. Are there resorts, restaurants or spas planned for your area? They don't have to be new: the extreme climate tragedies around the nation are all cause for rebuilding all types of places where your art might find a home. Focus your marketing and presentation using the "We" cycle phenomenon. You need to know who makes the art buying decisions for the restoration or new construction projects in your area. Learn their timelines, and if you will need to collaborate with other artists, a frame shop or art consultant, to have a chance at getting your art placed in them. (Often corporate art buyers and art consultants, or interior designers service finding art for the interiors of such buildings. Check my *How to Sell Art to Interior Designers* book for help in reaching those markets.) Doing this kind or marketing and research takes effort. It is an ideal job for your marketing assistant or virtual assistant to gather this information.

Most of the above is a discussion about looking for jobs where you can sell a lot of art at one time. The other side of the equation is finding individual art buyers, those who will become part of your loyal collector base. Surely, some will come from any large jobs you get, but most will come when you find them using one-on-one guerrilla marketing techniques. In the next chapter on networking, we will discuss the best ways to reach

your local community and meet your best prospects with the goal of converting them into loyal fans.

Building a database

As you begin to develop a list of prospects, you will need a way to organize and communicate with the people on that list. The best way to do that is through some kind of contact manager program. There are numerous free ones out there; just do an Internet search for "free contact manager." You will find many that are suitable. Depending on the size of your list, you may want to pay for a premium service that offers more ways to use the information that you are collecting.

For those on a budget, a basic spreadsheet will do. There also are several free Customer Relationship Manager (CRM) programs available from Google Chrome. Zoho.com also has a free CRM. Using a CRM will help you keep track of your prospects, and group them into such categories as collectors, galleries, art dealers, corporate art buyers, interior designers, media contacts, and so forth. Some offer the option of tracking your customers and prospects on social media. You can collect personal information, including birth dates, significant anniversaries, and more. In addition, your CRM will include a calendar to help you schedule appointments, note dates and give you reminders for critical events.

Part of successful guerrilla marketing is establishing ways to obtain accurate marketing intelligence on a consistent basis. You need to know what is going in the art market, both locally and nationally. You need to know what your competitors are doing. For instance, are they capturing new business because they have identified a trend that also fits the kind of art you are making? You need to know what opportunities there are to get your work shown in exhibits or sold in large quantities in construction and renovation projects.

The only way to stay organized is to use a database, or at least a spreadsheet, and preferably a CRM. Taking your time to decide what is going to work best for you will pay off in spades later on. You do not want to have to start all over with a new

system because you went for the cheapest or easiest option. Likewise, do not pick something that is so complicated that you get discouraged and never use it. The investment in time that you make to choose the best tools for you to create a contact database will pay enormous dividends in productivity and achievement in your art career.

i

Networking

What is networking?

Networking is about building relationships. It is about growing your business by developing both personal and professional connections to help you build a continuous, steady supply of new business. Ask yourself how many people you know. Among those people, how many of them actually know what you do, that you are an artist? How many of these folks have directed prospects to you? And, of those prospects, how many actually added to your bottom line by purchasing your art? If your numbers are low on your responses, this is a beneficial thing in that you have many fresh prospects for buying your work.

Networking is more than just showing up at the Chamber of Commerce or other local business-networking meeting, shaking hands and collecting a bunch of business cards. That doesn't work. Frankly, it never worked. Networking is about showing up with a *particular goal* in mind. It may be that you want to meet one or two people you do not know, but you think might be helpful to you. It could be that you are attempting to reach a specific person, as in the "six degrees of you" exercise discussed in the previous chapter. Start with good intentions and use your constantly improving networking skills to achieve your desired results. Finally, follow up efficiently, so your effort pays off.

Obviously not everyone you meet is going to be able to help you further your career and sell more art. However, you should focus everything you do while networking on your primary goal, which is to grow your business and find more collectors for your art.

Networking begins with a warm market

For anyone just getting started in networking, the easiest place to begin is within your warm market. Start by contacting your immediate family, and branch out from there. In every case, it is going to be easier to talk with people whom you know quite well rather than to talk with strangers. You may even ask some close friends to practice with you if you are not comfortable jumping right into networking conversations with them. The idea behind contacting your warmest market first is to make you feel more comfortable. That way when you start talking to people you do not know as well, or at all, you have already practiced those conversations, and have an idea of what you want to say. By practicing, you will not stumble over your speech. You will be able to deliver it smoothly and naturally, without any stress, like a pro.

I know many of you feel anxiety at the thought of speaking to strangers. You have to overcome those fears if you want to be able to network. Realize that those fears are unfounded. They are only your perceptions, and you can adjust your perceptions of about who you are, and what you are capable of achieving. All it takes is practice and determination.

Study the careers of the most successful contemporary artists, You will find it is their network–the people they know or have met through networking– who have helped them get to where they are today. In your own way, you can do the same thing, but you have to be willing to break out of your comfort zone and work at it.

Think about the people you know. What kind of occupation are they in, and how many other people do they meet through their jobs? You probably know at least a few people involved in the following professions: dentist, counselor, lawyer, doctor,

police officer, financial advisor, newspaper editor, and waiter. Many people would dismiss a food server as not being someone who could be of any benefit to an aspiring artist, but that is a generalization, and not always true. Typically, servers know many people, and it's highly likely that at least some of them see exactly the kind of people you want as clients on a regular basis. Servers can be connectors who can introduce you to those people. That is just one example of how networking with people—even those who may not ultimately buy from you—can help drive your career forward. Understanding this one concept of not discounting others on face value can be an enormous benefit to you in terms of making networking a tremendously rewarding and profitable venture.

Ask yourself this question: among the professionals whose services you use, how many of them know you sell art? How many of them have you asked to buy or view your art? How many have access to your marketing materials to share with others who might be willing to buy your art? If you are not tapping into this potential market, you are missing sales. Your dentist may not know you have art to sell. Your attorney or financial advisor may not realize that you have art to sell. If you have never told them, or they have never seen it, how would they know? Not every one of them is going to be a prospect, but their friends, associates, and clients might be prospective buyers of your art. Through their associations, they can lead you to others who can be immensely helpful to you.

It is a colossal mistake to pre-judge people and their potential. The only way you can know if someone is interested in your art and a potential buyer is if you ask if you can show it to him or her. If it turns out they are all Southwest with their design motif, they may not be a suitable candidate for your abstract art. Nevertheless, they could be the best prospect for introducing you to someone in their network who collects abstract art. If you dismiss your chances of success and never try because of some misplaced preconceived notions about the outcome, you lose potentially valuable contacts with someone else's network.

If you think you do not know that many people whom you could network within your warm market look over this memory jogger. You may be surprised to review this list and find professions and occupations that lead to names and viable networking prospects for you:

- Physician
- Minister
- Hairdresser
- Neighbor
- Teacher
- Counselor
- Dentist
- Supervisor
- Landscaper
- Housekeeper
- Best Friend
- Attorney
- Mechanic
- Fitness coach
- Nutritionist
- Decorator
- Apartment Manager
- Acupuncturist
- Friend
- Family Member
- Parent
- Co-worker
- Student
- Graphic Designer
- Retiree
- Bartender
- Lawyer
- Doctor/Nurse
- Carpenter
- Flight Attendant
- Network Marketer

- Chiropractor
- Police Officer
- Assistant
- Stay At-Home Parent
- Corporate Executive
- Plumber
- Artist
- Herbalist
- Veterinarian
- Musician
- Florist
- Mail carrier
- Waitress
- Editor/writer
- Psychologist
- Firefighter
- Photographer
- Volunteer
- Massage Therapist
- Financial Advisor
- Pharmacist

This is just a sampling to help you realize how many people you know from different walks of life. If you know people in these professions and jobs, or others, and they do not know you are an artist with work to sell, then you are missing easy opportunities to promote your work. You can safely assume most people you know like you. People buy from people they like; it is human nature. They also help people they like. Of course, not all will be excellent prospects, but you can never know if you fail to ask them.

You miss 100 percent of the shots you fail to take. ~ Hockey great, Wayne Gretzky

Some will buy, some will not, and some will become significant sources of referrals for you while others will not. It is all good, but only if you ask.

I had someone in a workshop who objected to the idea or working her warm market when I presented it. She felt it was the equivalent of acting like someone recruiting for Amway or some other multi-level marketing program. While I understood how she might think that way, I disagreed. First, I think she was throwing up a roadblock to avoid having to think about performing a task that makes her feel uncomfortable and insecure. That is a typical reaction. The only way to get over it is to get over it. No one ever was harmed or shamed because they mentioned to another that they sell art and asked the other person if they could show it to them sometime. The next thing to consider is that this kind of networking is not the same as asking someone to commit to joining some money making scheme. I do not like it when I am approached for those things any more than anyone else is.

The thing is that your art is a permanent piece of beauty and not the latest pyramid deal coming down the pike. You are on a whole other level when working within a warm market. You have something that *you* created, something that you are rightly proud to present. Most people are intrigued by art, you should take advantage of that. Some are intimidated because they feel they don't know anything about art. When you recognize that fear, seek to friendly, helpful and encouraging.

Asking casually and confidently to expose your art to someone you know should come easy to you. If it does not and you are willing to work on it, you can make that happen. Furthermore, when you do, results will also start to happen.

When you network, whether formally or informally, you need to have a purpose and intention why you are there. What is your goal? Is it to meet someone, anyone? Is it a more specific goal of reaching the organizer of a prestigious regional show or exhibit, or perhaps a gallerist, a curator, or an influential docent, for example? Your goal can be a small or large goal, or it could be both. Starting out with a goal in mind means that you are in charge, that you know from the outset what you

want to achieve from the meeting. Make sure you have marketing materials with you: a postcard (not just a business card) at the very least, or a brochure, to share with them. These days an iPad or tablet with a slideshow of your work, which requires no Internet connection, can replace a brochure. And, it is something you can easily mail to someone as PDF.

When you recognize a marketing maven or a connector, take steps to ensure you provide them with your postcards, brochures, or other marketing materials so they can share them with others. You never know when they might meet someone who needs what you have. You want them to be able to give that postcard or brochure to other potential buyers so they can contact you directly.

Just say "no" to business cards

Business cards are a terrible way to network. They are so 20th century. In my opinion, business cards allow prospects to slip off your sales hook and never get back to you. Virtually everyone I know is guilty of this. I have dozens and dozens of business cards that I've collected over the years. At the time of the exchange ritual, I usually had every good intention of following up with the person who gave me their business card, but in many cases I didn't. Why? Because, those altruistic intentions and warm, fuzzy feelings at the moment aside, it was just too easy to put the card in a drawer and forget about it. Business cards do not provide your prospects with a call to action. They are a lazy person's excuse for marketing. They give the other person a polite way to blow you off. If you need something from someone, do not accept a business card as a solution to achieving your goal.

Likewise, during more than thirty years in sales and marketing experiences, I have given my business cards to possibly thousands of people who I hoped would call me and sadly, they did not. The bottom line is do not carry business cards, or at least do not offer them until you are forced to do so. If the prospect is walking away and you are going to lose them anyway, then offer your business card as a last resort. At least the pro-

spect will have your name and phone number although you will probably never hear from them unless you take action. It is far better using a marketing piece that your prospect will not want to toss in a drawer, or worse yet, the trash. That is why postcards or brochures with color photos of your art should be used whenever possible over a business card.

If you are in a situation where you are exchanging information with a prospect, do not simply hand them your card or brochure. Take control of the situation by setting an agenda. Ask the person for permission to add them to both your mailing list and your email list. This is important: you need their permission to contact them again. You cannot accept a business card from someone and add him or her to an email list. That practice violates 2003 Can-Spam laws. Once you get their permission, suggest a time and place to meet. Ask to get together for a cup of coffee or to meet at your studio where you can continue the conversation, or to chat on the phone.

When it is crucial, do not conclude a meeting or introductions until you secure a commitment from the prospect to take your relationship to the next level. Say, "I will contact you. How does next Wednesday sound? Are you available in the afternoon? Would you like to come to my studio? I'm free in the evenings, and on Saturday afternoons, and by appointment." You get the point. You take control; you initiate the follow-up. By doing so, you stand less of a chance of being disappointed. Sure, some people may cancel when you contact them to confirm, but that is okay. You have made an effort and offer, and they have declined. You can now consider them off your list of sales prospects, at least for now because you may only know they are not interested now. By taking control, you have freed yourself up to concentrate your efforts on other opportunities more ready to purchase your art.

Do not leave home without a datebook and calendar, whether an electronic or old-fashioned paper kind. Do not go anywhere without knowing what your schedule is. That way, when you commit to a follow-up meeting with someone, you know you have the time to do it. It is also impressive and professional to pull out your datebook and schedule on the spot. To reiterate an earlier suggestion, always take the time to call,

email, or both to remind your contact of the appointment. This action shows you are a professional who values your time and your prospect's time, and how committed you are to furthering your career and your relationship with them. It is professional and common courtesy to be prepared and on time for your meeting.

You are a repository of information on any number of given subjects. Your expertise may go well beyond how to create outstanding fine art. You should make a point of freely sharing with others all the information you have available to you. Be generous of spirit in offering that information. This endears people to you and makes them want to be more useful to you. Besides, it feels fantastic when you are the solution to someone's problem, so work on understanding what you know that you can share with others, especially through networking.

As you increase your network, you will gain a powerful side benefit in the form of a growing list of people to introduce to others. You have a chance to become the glue in new relationships. Visualize yourself as one of Malcolm Gladwell's connectors. Can you imagine connecting your dentist with a CPA, or a web designer, or maybe someone to golf with or yoga or wine tasting? This happens every day. The more people you know, and the more you know about them, the more you are able to become a connector. As you build favors, they will proliferate and come back to you in ways you might never have dreamed of. You can predict when the two you connect meet that your name will come up with both feeling that they owe you a debt of gratitude. Multiplying such success will improve your art career.

To find out where your knowledge base intersects with your prospects' wants and desires, start by asking questions. Learn about their interests, and perhaps their problems. What's new in their lives? How are things in their business? Use this information to become a connector in your own way, a maven of sorts to help people solve problems through the community that you have developed around you. When they are looking for help or contacts of their own in your community, you can become a reliable resource for them. The more you share your

knowledge and contacts with others, the more it will benefit you and your business.

Making a good first impression

It goes without saying, but never be crass, brash, or needy when speaking with a prospect. As soon as people sense you are begging for their help, they won't want to do anything for you. It is a turn off. The same is true of tactless, rash behavior, or if you come across as condescending or arrogant. On the other hand, do not be so meek that you cannot make eye contact with your prospect because people may pity you, but are less likely to want to help you.

Be dressed professionally as if you care about your appearance. People take visual cues from everything about you. This does not necessarily mean wearing a suit or dressing in designer threads; it just means putting your best foot forward. If your hair is unkempt, your shoes are scuffed, or your clothes are outdated and ill fitting, you are putting yourself at a preventable disadvantage. Do not sabotage yourself with things you can control. Presenting yourself professionally sends a message that you care about your art and your business and makes you a more worthy candidate for whatever you are attempting to achieve through your networking activities.

Here are the keys to smart networking:

- Start small – work with family members and close friends, or other artists until you get comfortable with your conversation and approach.
- Do not apologize – never build in an apology. It is weak and unflattering to say, "Excuse me I'm sorry to bother you" or "I hope you don't mind" or use other words to preface with an apology. If you do this, work on ridding the practice from your vocabulary.
- Relax, be yourself, breathe – when you are anxious, it is obvious and can be uncomfortable for the person you

are with. Take a couple of deep breaths before you approach. If you feel nervous during the conversation, take a quick, short breath in before you begin to speak. This easy trick works for stutterers, professional speakers, and others.

- Smile with your eyes – smiles generate good feelings from others. The most genuine smile comes, not from the mouth, but the eyes. There is a discernible difference. A smile with eyes is genuine. It will help you, and your prospect to feel better about being with each other.

- Be generous – have something in mind to give to anyone who can help you. Suggestions for offers are mentioned elsewhere in this chapter.

- Be prepared – practice, practice, practice is how you got proficient at making art. Practice what you will say initially, what questions you will ask to set the tone for your conversation, and know exactly how you will ask someone to view your art, or make an introduction for you. If you think someone can help you, know how and why, and tell them first and then ask for a favor.

- Follow up – if someone is kind enough to listen to you, willing to meet you to see your art, or offers to help you in any way. Make sure you send an email, make a phone call, or a put a quick thank you card in the mail. The latter handwritten with your art on the card is by far the most effective way to follow up.

- Shed your fear – start with imagining the worst that could happen by you firing your courage up and jumping into a conversation intended to get you sales or introductions to prospects. If the worst does not involve your death, loss of family members or income, then your fear is unfounded. Don't be worried about what someone will think of you. If you act with dignity and confidence, the worst is you will be turned down. That's it. Quit worrying about things that do not matter and are holding your career back.

Elevator speech 101

The single most pertinent question you need to be able to answer fluently, easily, and naturally is this: what do you do for a living? It is perhaps the most common question asked in any networking setting, whether at a cocktail party, a formal networking session or an informal mixer with other business people and non-business social settings. This answer is an extension of your 30-second elevator speech. An elevator speech, or pitch, is what you say to a stranger on an elevator when you have only 30 seconds to say who you are and what you do before the elevator ride is over. Practice a concise answer to the question, "What do you do for a living?" Go over your answer repeatedly until you can deliver a flawless, yet natural-sounding response.

This reply should be something that you can answer quickly and easily while looking directly at someone with a smile on your face. It needs to be said naturally. You do not want it to sound like canned patter. But, you also do not want to be stumbling and grasping for words or stuttering as you think of the brightest thing that you could say at the moment. If you know in advance what you are going to say, and that your practice gives you confidence, it will come out just as you planned, then you will minimalize any nervousness or anxiety. To be most effective, your 30-second speech needs to be part of your daily arsenal of conversation starters, that is, something you can say confidently and repetitively. Don't just say, "I am a visual artist," or "I am a fine art photographer," or "I am a sculptor." While that may be somewhat interesting, it is rather dry and dull. Learn to put more meat on the bone when these opportunities arise.

Try to use action words in your sentence when you describe what you do. I create fine art sculpture. I create original oil paintings and produce stunning digital reproductions in various sizes for my customers. My Tuscany oil paintings are created for people to enjoy and to help them beautify and enhance their homes and businesses with unique, original imagery. Now, surely that's not going to be your elevator speech exact-

ly, but if you can take that format and then work on it and re-fine it, it will help you tremendously with your networking.

Take an entire day to work on your 30-second speech so you can say what you do for a living and with a concise, natural, friendly, and benefit-driven introduction. It will carry with for the rest of your career. You may revise it in time, it is so helpful to answer that question so you can turn your networking efforts into something favorable instead of stumbling and not knowing how to answer that question.

In addition, if your answer is enticing enough, the person with whom you are speaking will likely pose a follow-up question that opens the door for you to expand on your art or career. The comment, "Tell me more," can evoke a response, "my work is in collections in numerous corporate offices, medical buildings, museums, and private collections of notable people." You might take it another direction and talk more about how your collectors perceive and enjoy certain aspects of your work. Work until you can articulate the answer so that you can deliver it in a way that seems relaxed yet gives you complete control of the message that you're providing.

This takes practice, practice, and more practice. Many of the things that you learn to do as an artist come from repetition. If you learned to draw, it did not necessarily come to you natural-ly. The same is true of working on this part of your marketing strategy and making it the best it can be. You need to think about it, commit it to paper, write it, rewrite it, and practice it repeatedly. Get a recording device, or a webcam, or use a mir-ror. Repeat it to your family and friends until they agree that you are saying something that is powerful, polished and per-sonable. When you have that going for you, you will set the stage to begin achieving the goals you have set for yourself with networking.

The next part of finessing how you introduce yourself is in the segue. Now that you have engaged someone, and given him or her a brief background on what you do, and have fol-lowed up with a bit more information, you are ready for the next step. The next step is to ask for information about the other person. Perhaps start with, "Tell me about yourself."

"What do you do?" "How are you using this networking meeting to grow your business?" You may come up with six to maybe a dozen different questions you could ask in varied ways so that you have perfected the technique in terms of taking encounters to the next level.

The whole point of asking questions is to have the other person realize you want to get to know them. You want to leave them with the impression that you are listening intently for ways that you can use your expertise to help them in some way. They need to know you are genuinely interested in getting to know them, to know about them. By showing them that you can help them, you are taking the first step toward establishing a kind of symbiotic relationship with them, to further both your goals and theirs. Perhaps this will become a professional relationship or even a close friendship, who knows? Showing interest in the other person and their needs and then offering a potential solution to their problems is a fantastic way to impress them. This is how you make the first few minutes after meeting someone memorable.

Consider asking this person how most of their customers find them. Is it through word of mouth? Are they engaged in local marketing? How is what they are doing working for them? In turn, share the marketing techniques you have tried and explain if they are working or not, and why. You could tell them you have about how well your email marketing service works, or that you've found a particular networking group that truly stands out in terms of helping you find new potential collectors. Whatever it is that you are sharing, the fact that you are sharing makes you more open, and it is much more likely that someone is going to want to help you, as well.

The advantages of formal networking

Formal networking is where you set out to join a group or become part of an organization. A notable example is Business Networking International or BNI for short. It is the single largest group of networking organizations or local chapters anywhere in the world. About 4,000 local chapters of BNI meet weekly to

exchange leads and get to know each other's businesses. Although I have attended BNI meetings and have found them well worth the effort for some businesses, they do not seem well suited for visual artists. Getting to know the members would be helpful. Being tied to the schedule and demands would be a challenge for most visual artists

I do not believe formal networking of the BNI sort is beneficial for visual artists, mostly because members are required to be in weekly attendance and bring new leads to their fellow group members. Nevertheless, you can learn from them. Their motto is "Givers Gain." BNI tracking results confirm that those who benefit the most are the ones who give the most to the group and its members. Learning to give your time freely and share your networking contacts pays back. Other forms of formal networking groups include chambers of commerce, Kiwanis, and Rotary organizations, Business Women's Professional groups, charities, and nonprofits. Also, consider finding less formal networking events to attend in your area. Here in the Phoenix area there are numerous informal non-membership monthly networking events. Find similar events in your area so you can mingle with dozens of other professionals who are looking to socialize and to meet potential business partners.

How to make referrals work for you

I recognize networking can be a rather intimidating process for some artists, so taking on our next topic, referrals, might seem even more so for them and others. If it takes nerve to attend a networking event without personally knowing anyone there, then it is logical that to expect yourself to ask for referrals is more than you might get done on your initial networking activities. It is feasible that, as a networking newbie, you may go to a networking meeting, meet someone immediately and not use the opportunity to ask for a referral. You will find asking for referrals easier as your prospects' trust in you grows.

Knowing the best time to ask for a referral depends on how far the relationship progresses in the initial meeting. You will know whether you can comfortably ask for a referral. That said,

asking for referrals should become a standard part of doing business. If you are not asking people to refer you, you are missing an easy opportunity to increase your warm market. When you begin to succeed at asking for referrals, you will feel neither pushy nor desperate. It will become a natural extension of how you communicate with potential referral prospects

Givers Gain – the norm of reciprocity

A human interaction described as the norm of reciprocity is a powerful social custom. It simply dictates that we treat others as they have treated us. If I do a favor for you, or gift you with something, your natural inclination is to be more open to reciprocate. This dynamic works when you provide the referrer, and possibly the person whom they are referring to you, with a gift, some act of kindness, a useful introduction, or something special in another way.

Just asking if they know someone who might like to buy your art is not a particularly useful technique. It is far more effective to be specific, and ask about meeting people who are more likely to buy your art. The referrals you want to get should also be members of your target audience, as opposed to nonspecific prospective buyers. Maybe you are looking for architects, gallery owners, interior designers, commercial real estate brokers, or other groups. Giving your contacts particulars about your target audience helps them understand what it is you are trying to achieve. A side benefit is the person you are asking may become personally interested in buying your art.

Executing the norm of reciprocity means you are providing something to your contact to show them you genuinely want your new relationship to be about give and take. This is how working for referrals can produce extraordinary results. Formal studies have shown that when one person does a favor for another person, the recipient receiving the favor is much more inclined to reciprocate. How do you do that as an artist? You are probably not going to give an original piece of art to some-

one who might help you with a referral, but you could give him or her copy of your current catalog.

A wonderful, affordable option to create a portfolio is MagCloud, (It was recently acquired by Blurb.com). You can find details about it on its MagCloud.com website. You can use its services to make your catalog or portfolio in both online and print versions. At this writing, the minimum order for a MagCloud portfolio of 20pages was 20 units. Printing and delivery charges come to just over $60. That works out to about $3 each for a 20-page publication of your art. I urge you to check out MagCloud.com to learn how use it and create a portfolio. This marketing tool is one you can also use to promote your work, deepen relationships, and secure referrals. It is a potent guerrilla-marketing tool. It makes, in my opinion, the perfect gift to use when working on developing an effective referral strategy.

You might say to your prospect for a referral contact: "I'd like you to have my most recent portfolio as a gift to express my appreciation for you taking your time to get to know me. If you know others who also might enjoy receiving it, I will be honored to offer it to them, too. Specifically, as we discussed earlier, I am seeking introductions to interior decorators, architects, and gallery owners (substitute with your target audience), who might be interested in seeing my work. I can give you a copy for them, or save you the trouble and send them a copy with a note saying you thought they would like to receive my portfolio."

That is by no means word-for-word what I would expect you to say; it is merely a suggestion of how the model discussion could lead to asking for a referral. Plan what you want to say, in advance, and practice it. By practicing, you can make a conversation like this seem as natural as asking for a business card. Other things you might consider giving away are mini prints, note cards, or an exclusive discount. You could be giving out free art or posters. Perhaps you could provide art lessons or to arrange a live demonstration at a particular venue. The only limit on what to offer is your imagination. When you genu-

inely cultivate someone and give them an easy reason to recip-rocate, your chances of success improve.

To be successful, remember these things: be persistent; of-fer to give in return; always be grateful and responsive; and follow up with anybody you have a conversation with, even those who turn you down. A quick follow-up is an easy way to keep them interested. They may not be directly amenable to helping you, but if you continue to improve the relationship, good things can come from it. Being turned down initially doesn't mean that you will always be turned down. Usually a soft turn down comes with a reason why. It's up to you to de-termine if you want to pursue the possibility for referrals at a later date, or just write it off and move on to the next oppor-tunity.

Much of the previous discussion of networking and referrals was cast in the form of acting in formalized networking set-tings. The reality is you meet new people all the time. You do not have to make every conversation about you. With some people, you know you will be seeing them again at the next soccer game, church event and so forth. In those cases, work-ing on establishing a friendly relationship by getting to know people over time will allow you to work on creating opportuni-ties to show your art and ask for referrals. Some of it is a judgment call on your part. However, do not let fear creep in and cloud your judgment or keep you from actively working on developing new relationships, and asking them for referrals.

From reading this, you could imagine I advocate looking for new relationships five nights a week and on every weekend. That is not my intention, as I know it is unrealistic to think about, much less to do. Some more than others reading this venture out in public to socialize with others on regular occa-sions for all kinds of reasons unrelated to their art career. Whatever your pace for mixing it up, just learning some basic skills to help you advance your career goals is useful. Do not take opportunities to use your networking skills lightly. Re-member if you are acting in good faith and seeking to help oth-ers first, no one will ever think of you as some shallow, "It's all about me" person. On the contrary, if you truly work at it from

the "givers gain perspective," you are likely to be the most popular person in the room at events you attend.

Overcoming your reluctance to public speaking

Public speaking arguably is the most dreaded fear for many people, but it does not have to be that way for you. Anyone who has the desire to learn can become an effective public speaker. I know some of you may not believe that, but it is true. I worked with an editor at *DECOR* magazine who, in her spare time, was a prolific writer of fantasy and young adult novels. Her fear of public speaking was almost morbid. To stand up in front of a group of her colleagues with whom she worked with daily, and to speak to them made her tremble so visibly that it was painful to watch.

Now, she often speaks at public book signings and does it remarkably well. She has managed to overcome her fear by practice, and with that confidence she could conquer her fears, and so can you. If you are ready to do this, it is a brilliant way to promote yourself and your art, and become well known in your local community. I recommend getting a copy of Mac Keynote, Microsoft PowerPoint, or the free Open Office Impress presentation software. You will need a digital projector or to borrow one. Create an outline using your presentation software. There are many useful sites on the Internet that will help you learn how to create a PowerPoint presentation.

Once you start practicing with these visual aids, your ability to present your material will become easier. As you become accustomed to hearing yourself talk about a subject you are interested in, you will be taking monumental first steps toward being able to speak in front of groups. You can start with making presentations to your family and friends. Once you have mastered that, you might want join the local chapter of Toastmasters International. They help people learn how to speak in public. In Toastmasters, you speak privately just to the group. The groups are anywhere from five to ten people, sometimes larger. Your peers will provide constructive critiques about your speaking, your physical demeanor, and your slides and content.

Overall, with practice and determination, you will develop a sophisticated, professional presentation style.

So what do you talk about? One thing you do not want to talk about is your art. People do not want to hear a 30-minute sales pitch. Instead, uncover some art-related topics that will stimulate their interest. Perhaps you live in a culturally rich community and could discuss an upcoming exhibit at a local museum. If there is a particular artist who was born or lives in your city or state, you could develop a slide show and talk about that artist. Your presentation could be about a famous artist whose work is currently on exhibition. Your speech could be about the life of Michelangelo, Leonardo da Vinci, Pablo Picasso, or Georgia O'Keefe. Anyone who was instrumental in creating/fostering an art style or who inspired others would be a proper subject. If you are able to weave practical business or life lessons into the talk, you will open up dozens more opportunities to present your speech.

Consider giving a talk on art history in your town, county or state. Explain how art has changed lives in it. Anything you are passionate about will make for an interesting speech. You could talk about how arts enrich a community. In an op-ed piece on the AZCentral.com website,

[http://www.azcentral.com/opinions/articles/20130301arts-more-valuable-to-community-than-just-entertainment.html] Ben Cameron details how arts enrich a community.

Here is an excerpt:

> *A recent report from Philadelphia — a city characterized by a robust community of government, individual and foundation arts supporters and one slightly larger than Phoenix in population — reveals that the arts community there now accounts for $3.3 billion in local economic activity, supports 44,000 full-time jobs (roughly 80 percent of which lie outside the arts proper — jobs like accountants, construction workers, caterers and more) and stimulates an average of $30 of expenditure per person per event above and beyond the price of a ticket, the vast majority spent outside the arts venue.*

Do the research to demonstrate how arts benefit your community. Then learn to make it available in a presentation to

civic groups and other organizations. Doing this will open numerous doors for networking and referral opportunities. The side benefits of promoting the arts and educating their value are incalculable.

If you are willing to do the research to supplement what you already know, you can expand your passion into a 30-minute to one-hour presentation. You will be amazed at how long you can talk about a topic you know something about, especially once you organize your thoughts and create visual aids to help illustrate your points. After you make a few of these presentations to local civic, social, or business groups, it is possible you will become their "go to" person on that subject. People will come to see you and learn what you know, and of course, you are then going to be able to say that you are an artist whose art is for sale. Public speaking can introduce you to people that you would not have known otherwise, and some of them may become your biggest collectors, supporters and benefactors.

A final word on marketing yourself to your community: if you want to meet potential buyers, you must spend time in places where those types of people meet. Attend art shows, museum openings, charitable events, and art walks. Be seen at other community events where potential prospects socialize. If you're not accustomed to being in the company of people who are good prospects for you, spend some time at these events. Try occasionally dropping into the most lavish department stores and boutiques where they shop. Visit display homes that are out of your price range. Get a feel for who these people are, how they spend their time and what they might like.

Recently I was at a BMW dealer where I had purchased a used car a few years ago. As I looked around the showroom, I realized that the lobby resembled an automotive display palace. The sales people were immaculate in suits and ties. Some of the cars on the showroom floor sell for hundreds of thousands of dollars, well beyond my means. As I looked around, I knew I was not nearly as wealthy as many people who buy cars from this dealer. Still, just by being there, I got a taste of who the high-end BMW-buying person might be and what makes such an individual tick.

Doing this is not walking a mile in the shoes of potential wealthy patrons. It does put you in the mindset of your potential collectors. Just glimpsing everyday activities in their lives can help you be more comfortable when working with them. To some degree, this is studying your target audience. If your work is at the luxury price points level, then having an understanding and feel for how the luxury buyer of your art lives can be helpful in your marketing and your sales. While you may not be able to keep up with your luxe prospects financially, you can visit places where you can observe the world they live in, and share experiences they experience daily.

Does this sound silly? Do not let such a notion deter you. You have a marketing job to do. The more you are able to experience and gain small insights into the lives of your potential art buyers, the more relaxed and natural you will feel when presenting your work to them. Perhaps your work does not fall in the luxe category; then adjust your research and experiences to the level of the buyer most likely to connect to your art. You can reach your potential collectors in many other ways. We will cover some of them in the next chapter on traditional marketing.

Learning and using networking skills regularly will put you in direct contact with many more prospective collectors than running ads, pitching galleries, hanging out online, or other forms of marketing. You never want to limit your marketing to just a few ways when so many are available, and you should never assume that by doing other marketing activities you should ignore networking and the power of it..

If you are both struggling and ambitious, or just eager to advance your career to new heights, then work on networking with your best prospects. I am talking about those that can help you fulfill your goals, and who I hope are at the top of your list. It is not just your direct prospects, it is whom they know, and it is the people whom those people know that will help you discover possible career game-changer contacts. Besides, should such a game changing person remain elusive to you, you will still have built an impressive collector base in the meantime. There is no downside to successful networking. It always adds value to your career.

Traditional Marketing

Defining traditional marketing

Traditional marketing consists of "old school" methods of getting attention for your work. These include print advertising, press releases, direct mail, networking and referrals, word-of-mouth marketing, local marketing, and event marketing. Event marketing includes exhibiting at juried shows; trade shows; open studio tours; and alternative venues, such as occupying temporary space in an antique mall.

Traditional marketing is immensely useful in helping support social media and other online marketing activities. It will drive traffic to your social media, blog and website with impressions from print ads, publicity, press releases, direct mail and other traditional marketing strategies you use, it builds credibility all around. Traditional marketing also creates links from an offline form to online. Any marketing activity you're going to do, such as print advertising or direct mail should always have a link to your website, blog, or Facebook page. An effective guerrilla-marketing tactic is to make sure that whatever type of media you are using it supports related activities and programs whenever possible.

It is possible that you can reach more people with print advertising than you can with social media. Your social media sphere is only as large as your Twitter followers or Facebook fans. When you buy an ad in a magazine with a 20,000 or 100,000 circulation you potentially reach many more people.

With traditional marketing, you can allocate your marketing budget among various techniques to avoid having all your marketing eggs in one basket. Make sure your messages include the design and graphic elements and other components that you developed with your personal branding strategy.

Traditional marketing carries your logo, graphic elements, and other features that make your advertising and messaging unique to you and your business. I believe you will find traditional advertising gives your business more substance, in some cases. It makes you look bigger, more professional, more as if you have arrived than companies that are purely an online play. There is no doubt that some aspects of it can be expensive. As such, print advertising may not be the best choice for every artist, but it is worth considering when your other bases are covered, and you have funds to apply it.

When it comes to things like publicity and press releases, the cost is minimal compared with buying a flight of ads in a print magazine. Traditional marketing vehicles such as shows, PR events, in-gallery promotions, or print ads give you something to talk about in social media. You will want to record the activity and publicize it on Facebook, LinkedIn, or Twitter. It gives your potential buyers and collectors another reason to follow you.

To recap, traditional marketing is a broad category that can incorporate as many, and more, of the following elements as possible, given your budget and goals:

- Press releases
- Publicity
- Postcards and direct mail
- Networking
- Referrals
- Word-of-mouth
- Local marketing
- Event marketing
- Alternative marketing
- Print advertising
- In-gallery marketing

Gallery marketing is also a component of traditional marketing that has been around for centuries. Some artists think that the gallery system is passé. I disagree. Although it is true that the gallery system has changed, it is not going away either. Smart artists are engaging galleries in new ways and helping them promote their work, and at the same time, they are doing what I call "carrying their own water." This means visual artists do not need to rely solely on galleries to become successful. That said, gallery representation and partnerships still hold value and prestige for artists. In other words, galleries remain a viable, valuable marketing channel for artists.

Study the market and you will learn successful artists today are discovering ways to build bridges to collectors so they can sell to them directly. Smart galleries realize the game has changed. They can no longer stipulate that an artist cannot sell directly to the public. Everybody has to make a living and has the right to make a living. Unless a gallery owner can guarantee you will earn enough money to make your lifestyle work, then they cannot stand in the way of you selling your work through other distribution channels.

You want to treat your galleries with respect, meaning you should never price your art lower than they do. To avoid this potential conflict, I recommend that you do not sell the same art directly to the public that is available in-gallery. I also recommend that you promote your galleries by including links to their websites on your blog, in social media, and on your website. By doing so, you show genuine interest in being a "marketing partner" as much as an exhibiting artist.

Why Direct Sales Discounting Is Harmful

A word on discounting when making direct sales; besides putting you in conflict with your gallery, you are doing yourself a disservice. Price your art competitively to begin with and keep your prices consistent across all your distribution channels. Discounting below gallery prices costs you money and harms your pricing and personal integrity. You will never find a retailer at blow-out prices for Apple products. It is a sure fire

way to lose the right to distribute its products. Likewise, you can't go on Apple's website and order products that undermine its distributors. This way, consumers buy where it is most convenient and not because one partner in the distribution channel was undercutting everyone else.

To learn how develop relationships with galleries, you will find Jason Horejs' definitive book on the subject, *"Starving" to Successful: The Fine Artist's Guide to Getting into Galleries* as an excellent resource. I highly recommend it. Horejs has spent many years delivering four-hour workshops all over the United States and Canada on his methods. He is the son of an artist who has raised a family of nine as a self-supporting professional artist for more than two decades. He also owns a highly successful gallery on prestigious Main Street in Scottsdale, Arizona. In his book, Horejs imparts the wisdom and insights that only come from experiences like his.

If you are going to do gallery marketing, you need to build a database of the galleries in your target area. Start with the names and addresses of all the galleries in your local community, and then working outward concentrically to larger and larger areas so that you do not miss any stores that are close by you. Select galleries based on how well they mesh with your profile as an artist. For example, don't waste your time calling on a gallery that represents only photographers or sells abstract art when your work is figurative. Pick your battles. Know which of the galleries you learn about need to be on your target list.

Make sure you include picture frame shops in your research. You should know every one of those in your area. Get a bead on which ones are prospering. Make friends there. Picture framers are repositories of valuable information for artists. Quite often framers are in the gallery business; they know many of the galleries in their local area and can be a significant source of information for you. In some cases, they can also help you sell your artwork. Thus, work on finding ways to befriend and develop relationships with all the picture framers within your local and regional market. Thinking back, remember

with all networking that givers gain. What can you do for them? How can you help them?

A perfect example of building meaningful relationships through networking and referrals

For more than two decades, Rob and Barbara Markoff have owned and operated a thriving frame shop in San Diego, CA. Barbara also runs a highly successful corporate art consultant business from the same location. Because corporate art involves providing finished, framed art, this is a perfect combination of businesses. Barbara is the author of *How to Become a Corporate Art Consultant*. Whether you are interested in that business for yourself or just want to learn about the corporate art aspects of the business, I highly recommend her book.

Can you imagine how making someone such as Barbara a colleague could help your business? She is a perfect example of tying the need for specific goals that include getting on the radar of valuable contacts, with networking and referrals. It all comes together when you think of this one relationship. What happens if you develop ten, twenty, fifty, or more professional acquaintances or friendships with influential people? Such folks are busy and usually do not tolerate having their time wasted. When you attempt to get to know them, know what you want, what you have to offer, and always be respectful of them and their time, and grateful without being needy.

Good guerrilla marketing techniques involve studying your targets and learning what they do so you can effectively market to them based on their needs and their terms. It is the difference between showing up asking for help selling your work and showing up offering to solve problems with practical solutions. You cannot do that without doing your homework first. This is just one example of how to get inside the head of those people who can help your career flourish.

Remember: To be successful at anything, including gallery marketing, you need to set a goal. Maybe yours will be to pick up five new galleries in the first year, or 10 in the next two years. You might want to do more, or less, depending on what

else is happening in your business and in your life. By doing your research, you may cut down the number of galleries you approach, but at the same time increase the probability that those you pitch to carry your art will want to do business with you. When you combine art suitable for the gallery with an enthusiastic attitude, and come and ready to bring your own tribe and marketing to the equation; you significantly up your chances of landing gallery representation.

Snail mail is alive and well

Direct mail, that is, postal mail is far from dead. Yes, it has taken a beating in some ways, but now many marketers are using it more frequently because they know they can get their message to their target audience—their top prospects.

You cannot just send an email blast to anybody you want to; that is illegal. You need to have an opt-in list before you can start sending out a broadcast email. With direct mail, on the other hand, you can buy or rent lists. There are resources in the back of this book that can steer you in the direction of some of the better mailing list brokers. You can also trade lists, or offer to send out a mailing for another business using your list if that other company is willing to do a mailing in kind to their list. This exchange works best with businesses whose audiences are similar in scope and interests, such as other artists, picture frame shops, galleries, or a local fine art photographer. Use your creative genius. Stretch to think how many different people there are who might have a potential file that you could use to promote your art. Contact them to offer a residual benefit for them from marketing to your list.

In addition to buying and trading lists, you can also rent lists from magazines. Many magazines will do a mailing for you. They usually won't give you their subscriber list. Instead, you will send your pre-approved materials to a bonded mailing house that will deliver the direct mail piece for you. If you also are an advertiser with a publication, you should inquire about reduced rates for using its list as some sort of value-added proposition. Magazines sometimes offer loose inserts that go in

a polybag with the magazine. If you are going to do business with a print publication, make sure you learn about everything it can do for you.

Your intentions should be to collect as many email and mailing addresses as possible. Give people a reason why they should be providing this information to you. Perhaps give them some mini prints, notecards, free shipping, discounted framing, whatever it is that works for you and is enticing for the potential customer. I am a proponent of using postcards for direct mail versus stuffing pieces in an envelope. Envelopes add cost and recipients have to open the envelope before they can see your message whereas a postcard puts your artwork directly in that person's hands.

I believe in using oversized pieces, at least 4-by-6 inches, if not 6-by-9 inches, because the larger they are, the more they demand attention. It is quite hard to ignore the message when you find something of that size in your mailbox. If you insist on envelopes, you will want to get creative. You can order envelopes that are translucent so the recipient can see through it to its contents. If you have the right images, this could be a rare, intriguing option, different enough from a postcard that it would entice someone to open it and see what's inside.

Remember: when it comes to direct mail or other kinds of marketing you may not have the expertise to write the copy or create a graphic design. I previously discussed hiring a professional copywriter and a graphic designer to develop your personal branding. Consider bartering or using them to contribute to your ongoing marketing pieces so that you have the best possible messages with the words and appearance of your marketing pieces. A direct mailer is your salesperson when you are not there. It is an investment in your business. This means you want your copy and design to be spot on. Direct mail is not cheap; cutting corners on the content does not make sense. Include the cost of professional help with your printing, list acquisition, and postage before you commit. That way, you will understand the full cost and can budget accordingly.

All press is good press

Press releases are perhaps the most underused free, or low-cost resources artists have available to them. Many artists do not accept or believe that they are press release worthy. I recommend that you visit my Artprintissues.com blog and use the search box on the right hand sidebar to search for "press releases." There you will find numerous articles explaining in detail how to write a press release, where to send a press release, and the free press release services available to you. Tara Reed teaches artists how to succeed in the licensing market. She has a superb e-book entitled *How to Be a Press Friendly Artist.* It is full of useful information. (Details are in the Resources section.)

There are many reasons people would like to read about you. These include you have hired someone, moved to a new location, were acknowledged by a magazine or an organization, or have become president of your local association. The news need not necessarily be about your art business. It could be something else about your business that is intriguing enough for people in your community to want to know about it.

Issuing a press release is casting a net: you send your item to thousands of potential journalists who may pick it up on the press release wires or through Google alerts. Some may actually attempt to contact you if they find your news appealing or appropriate, but the chances of that happening are not in your favor without an extraordinary hook. Don't dismay because that is not the primary reason you use press releases. Your press release will get you attention, you can post it on your on site and in social media, and it is useful for search engine optimization (SEO) purposes. That means that your press release, if done correctly, contains keywords that relate to your business. When someone conducts an Internet search using those words, SEO helps your press release get noticed and found on searches containing your keywords. Your press releases also will contain links to your website and/or blog, which both helps your SEO practices with quality links, and opens new ways of driving people to your online presence and business.

If you are not an expert with words as encouraged throughout this book, consider hiring a professional copy editing service to help write your press releases. A list of such services is included in the Resources section of this book. At the least, consider the option to buy grammar checker software. Even the best of these are not perfect, but they will help you to create the best copy possible. Use the tools, training and help the press release services freely offer to make your copy shine.

No publicity is bad publicity – Art Is Sexy

Press releases are something that you push out to the world. You hope to get noticed due to letting others know about what is going on in your business. Publicity is the coverage you receive–a magazine or newspaper article, or a mention in a blog, on a TV or radio program–through your relationship with people in the media. Yes, artists can get on TV. We don't realize it because it's just part of the fabric of our lives, but the amount of media around us is enormous. Just look at your local listings.

How many radio stations, television stations, magazines, and newspapers serve your local community? Add them up to find a gigantic media monster that constantly needs new stories and items of interest. Stories like yours are necessary so they can publish commentary on issues or air programs and attract readers, viewers and advertisers to those kinds of stories. From this perspective, artists have much more to offer than many other types of businesses. As an artist, you create beautiful pieces that draw attention. Couple that with donating your time and art to benefit a local charity, for example, and you have a tailor-made story ripe for garnering free publicity. You will find this easier to do than, say, a plumber or a chiropractor, because art has a somewhat sexy charm that other types of businesses do not.

If you are truly serious about achieving as much positive publicity as possible, you may want to hire an agent. Publicists already have the media contacts you need. They know which newspaper editor is looking for a story on artists and charity

work, for example. And they know how to pitch a story idea. Think of a publicist as an agent to help you get media exposure for your business.

If you are not going to use an agent, you will have to do the research yourself. You will need to assemble a database of all the media in your local area, and ultimately national as well, and add the contacts at those media outlets to it. Then you need to start putting names and faces with the potential best person to contact at each one of those media outlets for possible stories. As you are doing this research, you might also take some time to see which businesses are getting exposure in your area. Find out if any of them use a publicist. You might encounter a publicist who you initially thought was too expensive to hire but, in fact, is worth every penny they charge when they get results for you.

Almost all daily newspapers, weekly papers, and many of the lifestyle magazines in your area have people on staff covering the arts. Some of the larger outlets employ people specifically to cover visual arts or galleries. You want to befriend them, follow their careers on Facebook, Twitter and LinkedIn, do Google searches to find out what they have been up to, and use Google alerts. You can set up a Google alert for any kind of keyword phrase and have the results delivered to you at the end of each day or once a week, for example. Search for the person's byline, their column or their employer.

This analysis helps you to understand who these media sources are and what they do. Armed with this information you can begin to do such things like sending them congratulatory notes when you see that they've received an award or they've written an excellent article. You might send them story ideas. Go on their blog and post useful, insightful comments. Media types usually are accessible. Many are more welcoming at public events. If you know they are going to be out at an art walk, gallery opening, or some other charitable event, seek them out and introduce yourself. Tell them who you are especially if you have already sent them a congratulatory note, contributed blog comments, and if you have had other communications with them that you can use to break the ice.

Find out what organizations they support and make it your business to be seen by them at those organizations' events. Do they have any outside interests, play tennis, race cars; grow tomatoes, or the like? Anything you can learn about them that makes a conversation with them easier gives you an advantage over others seeking publicity. People do business with people they like. They have choices, and the more you can influence them, the more you will enjoy public relations success.

By getting to know a journalist, and making it easy for them to know you, it is much less stressful to approach them and present story ideas. Position yourself as an authority on art–yours or art in general–and let them know you are ready to become their "go-to" person on the subject. If they like you and your art because you have gone the extra step to cultivating a professional relationship with them, you will be more successful than artists who send out unsolicited requests for publicity. I have already encouraged you to start doing public speaking on relevant topics. You can see now how having such stature can elevate your game with media contacts.

Promotion also includes free media opportunities. Consumer magazines, trade magazines, and directories all publish regular columns that are compilations of news about people, artists and artwork. Many publications have established publicity columns where they request submissions. These present easy opportunities to gather notice in local, regional and national magazines. Keep in mind the column titles change and so does who edits them from time to time. As such, it is necessary to keep your research current. In order to know which media outlets can reach your target audience, explore the kinds of articles they publish, and then put together a story that is just what they are looking for. If they want a picture and 50 words of copy that is what you should send them.

You can download the advertising and media kits from media sources. They used to make it much more difficult to find information from them, and usually required contacting an advertising representative and listening to a sales pitch before you could receive it. Now nearly all media sources make this information freely available online. Search their website and

you will find not only advertising rates and how to submit press releases, but their editorial plans for the coming year. This may include a comprehensive list of items, a calendar of more detailed planned stories for their next few issues, and other useful information, including audience demographics. Look for tie-ins to these topics that you can use to tailor a story to their needs so you can receive free publicity for your art.

Make sure you understand the deadlines for publicity submissions as well as the publication's preferred way to receive them. Is there a word limit? How many photos will they accept, and of what size and resolution? Do they need jpegs or tiffs? You can send samples to create your own online magazine and then use these affordable copies to show them your work, or direct them to a special "Press Section" on your website. It is a lot of work, but publicity can be immensely influential in helping you reach your marketing goals. *The third-party implied endorsement that comes with publicity is invaluable.*

Advertising can be affordable

When it comes to print, radio and broadcast advertising, the first thing you need to know is that advertising rates vary and often are negotiable. As such, I once again strongly recommend that you brush up on your negotiation skills. The resource section of this book includes several books on the topic. Read books on negotiations to improve your ability to deal with advertising reps and anyone in a situation where a potential difference in what you are going to pay and what they want you to pay exists. You negotiate rent, positions and rates at trade shows, and you negotiate for added value from media. For instance, if I agree to buy advertising, what added value services can you offer me? If I buy a booth at this show, what extras can you give me? The better you are able to negotiate, the more money you get to keep in your pocket, or the greater visibility you gain without additional expense.

Effective negotiation is not about taking advantage of people. Start with the realization there virtually always is flexibility in rates and terms. Your goal is to get the best deal possible. If

you can arrange a five or ten percent gain in every deal you do, over the course of your life that can count to hundreds of thousands of dollars, or more.

When it comes to consumer advertising, you may find that, for the most part, it is too expensive for independent artists. Advertising works, but it is not a one-time marketing strategy. To be successful, you must advertise on a consistent basis. Unfortunately, three-, six- or 12-month advertising contracts, even for a small ad, can be too expensive for emerging or mid-career artists.

I sold advertising for many years for *DECOR* magazine. Before its stellar 135-year run ended, it was a highly regarded trade magazine read by nearly 30,000 galleries and picture frame shops. I often heard from artists who wanted to buy one ad. I would ask if they were planning additional advertising. Many times they would say, "No, I am hoping to make enough money from that ad to buy more, and if it works that is what I will do." I encouraged them to keep their money, take a vacation to some incredible place because a single ad in one consumer or trade magazine is a waste of money. For print advertising to work, you need to run on a consistent schedule, such as a minimum of three times, or better yet a six- or 12-time schedule. Otherwise, it is a waste of your valuable marketing dollars. Print advertising works best when it is supporting other kinds of marketing. Including it in the variety of other things you are doing is the only way you should consider using it.

There always are exceptions to rules. This is true of advertising. One place I find artists getting a decent ROI running one-time ads is in a collector's guide, which are available in most gallery districts. Advertising like this can be beneficial. These publications typically are far less expensive than other consumer media. They singularly focus on your art collector target audience, and they tend to have a longer shelf life. As such, it is more likely serious collectors will keep and refer to them more than once. On the other hand, most consumer magazines have a shelf life of about a month during which time a reader might page through it one or two times.

When you look into using collectors' guides, or advertising in consumer magazines, check out how many artists repeat advertising in these publications. If you notice that there are artists who are continually using this media, there is a decent chance that they are seeing a decent return on their investment. That knowledge should give you more confidence to forge ahead and negotiate a fair price for yourself. Don't be shy. Consider contacting some of these repeat advertisers to ask them about their results and their rates.

Another way to advertise is through co-op groups. You may have seen these ads, where members of local art groups or several art galleries collaborate on an ad and split the cost. This is one way to afford a larger ad with more presence and a much wider circulation than you could manage on your own. Xanadu Gallery in Scottsdale has shown ongoing success with this kind of format.

When negotiating a price for your advertising, play hardball, if necessary. Ask the salesperson who has quoted you a rate to put in writing that no other advertiser at your level of commitment, meaning nobody else who has purchased a three- or six-time contract, for example, is getting a better price than you. You should not have to subsidize a competitor who is a better negotiator than you are. This is one way to avoid that. No reputable ad rep is going to commit to misleading you in writing. This is last resort negotiating. When negotiating for ad rates, consider using other less confrontational methods to achieve your goals. Nevertheless, it is your money and your business, and you need to make sure you are on solid ground and getting the best deal possible.

Previously, I mentioned the term "value-added." Many media companies, especially magazines, have value-added services. These might have included free or discounted direct mail list rental; free or discounted direct mail email blasts; enhanced publicity opportunities; and the like. Some magazines consider editorial and sales two separate entities, like church and state. They will tell you that buying advertising does not guarantee editorial coverage. However, when you buy an ad, some other media will bend over backwards to feature you in articles. This latter scenario does not often happen, but you will not know

until you ask for it. Doing your own research on a media company's advertising policies is the best way to know how to proceed. Your rep can be a tremendous source of information, but do not rely strictly on what you learn to make decisions. Make sure you prod them for every available marketing, editorial and publicity opportunity.

Thinking outside the box

Alternative marketing can help you find collectors and reap rewards. It might be in the form of artist co-ops where your guild or association produces an annual show or event. It could be you and other artists getting together to put on a show just before the holidays, or at some appropriate seasonal time, presented as a studio tour, or possibly in a rented location. You could create an art happening. With so much vacant commercial real estate, you could gather a group of artists to rent a temporary space that would not require any build-out, to use it for a month, or maybe two months.

You see stores pop up in malls for Halloween and Christmas. Use your imagination to come up with your own alternative marketing to model along the same lines. Work on creating an event that is fresh and unique, something art buyers will find attractive. Consider bringing in other kinds of artists such as musicians, actors, and poets. The cross-pollination of your lists and contacts could introduce you to many new prospects. Art roadshows in Costco stores have been going on for years. The gallery I worked for in Scottsdale regularly participates in them. I staffed the booth at several Costco roadshows for it and know firsthand it can be a lucrative way to get your art seen and sold. Individual artists without an extensive fully framed print line are not prospects for Costco, but you can model how they are setup and look for suitable venues for yourself, or a group of artists. You can also consider a proposition to those companies that do the roadshows.

When you create a new kind of art happening, good things can happen. It could easily garner free publicity. When you are in the driver's seat, meaning you are the person who is direct-

ing the proceedings, you are the one who will be the contact person. As a result, you can expect to get the lion's share of the media attention. It could be not only a fun event but also a highly profitable one. Done right, it might even turn into an annual event.

Other forms of alternative marketing involve developing relationships with the owners of coffee shops, restaurants, boutiques, spas and furniture stores where you can hang your art and gain much more exposure. This kind of marketing is not suitable for every artist, but it might work for you. There are artists who are making a thousand dollars, or more, a month by selling in coffee shops and restaurants. Boutiques are excellent places, as are beauty salons. For a long time, I got my hair cut at a trendy salon in central Phoenix that doubled as an art gallery. The spouse of a friend for many years owned a skin care salon in Paradise Valley, it has the highest per capita income in the Greater Phoenix area. She doubled the space functionality by operating an art gallery in the spa.

This is a shining example of an entrepreneur who has targeted people with disposable income, those who come on a regular basis to the salon for their skin care treatments. She made the most of those connections by also exposing those high net worth potential buyers to art at the same time. Additionally, she hosted regular art events at the salon, which included inviting new and repeat customers to the salon, and had her artists do their own marketing to generate more traffic and synergy for the event. For all involved, it was a win-win situation.

Be where your customers hangout

Another example of a successful alternative marketing story involves one of the top sellers on the Fineartamerica.com website. This online gallery offers artists complete fulfillment for fine art prints, including framing. The subject artist here records sales of about $10,000 a month by selling her automobile themed art. The art does not sell itself. She attends the numerous car shows in her area, takes interesting artistic pho-

tos of the cars, and then hustles there to generate sales in her prints. The shows are her primary means of finding customers. She goes where her customers congregate. She makes the art, finds the customers and uses FAA to print and frame her work and deliver it to the customer. Because she knows she can rely on FAA, imagine how much more time she has to work on creating and selling art to take care of her billing and fulfillment.

It is true with not just online sales and fulfillment companies, but with any other method you have of getting exposure for your work, that you have to take responsibility for driving traffic and making sales. It is about identifying and using the best tools to help you sell your art. When you accept full responsibility for getting your customers excited about your work by using the most suitable art marketing tools, you will succeed at selling your art.

I once spoke at a local art league's monthly meeting where plans for promoting its annual open studio tour were discussed. I mentioned that the members should not rely on the marketing from the association as their only means of driving traffic during the show days. Afterwards, the director told me too many of the participants do little or no promotion for the show and then grumble about their results. She thanked me for encouraging members to do their own promotion for the show. It is back to my previous statement about the fact that you cannot rely on others to carry your water. When I repped for Decor Expo shows for nearly two decades, I regularly encountered this same exhibitor inaction and likewise the same unhappy exhibitor reaction. The show will do its part to bring in customers, but the exhibitors who get the best traffic and results were the ones who did their own marketing. Never expect anyone or any organization to be the driving factor in helping you increase sales and discover new buyers. That is a recipe for failure.

If you expect to achieve outstanding results, you have to be responsible for making it happen. You will fail if you sit back and hope others will do your marketing for you. Rather, consider how you can develop relationships within affinity groups, such as with the top selling FAA artist selling automotive relat-

ed art. Finding a niche is a powerful way to narrow your focus and strengthen your sales within it. Correctly, studiously and ambitiously applied, alternative marketing can be extremely rewarding both professionally and financially for artists who develop an encompassing strategy to promote and market art within a niche, or in an alternative marketing channel.

Marketing Art Online

Digital marketing, as the name implies, has everything to do with having a presence on the Internet. The process involves you working to establish your piece of real estate on the Internet through digital marketing, and then to leverage it to help you gain awareness for yourself and your art. That is what all marketing is about, digital marketing included.

At the heart of digital marketing, in my opinion, is a proper domain name. A domain name is your universal resource locator, or URL, on the Internet. Mine, for instance, is BarneyDavey.com. For branding and recognition purposes, I recommend artists use their name as their domain name. If your name is already taken, you can adjust it by adding a word or words, such as BarneyDaveyArtist.com, BarneyDaveyGalleries.com, BarneyDaveyStudios.com, BarneyDaveyFineArt.com, or some such variation.

If you have established an online presence with the name Evergreen Art, for example, and have spent time and money promoting it rather than your name, it may or may not be too late to turn back. You have to decide what works best for you.

My suggestion, in most cases, would be to consider obtaining a second domain name that includes your given name, and over the course of the next 18 to 24 months, migrating to that new name. It is not the end of the world if you do not follow this advice. If you have an established domain name in the marketplace, and you have some branding that you have in-

vested in, you do not necessarily need to lose that branding. Instead, you can set up your web presence so that people who find you by searching for Evergreen Art are automatically forwarded to your new domain name. This is just an idea if you stick with your company name that does not include your proper name; it need not fully impede your online success. Should this be your decision, my recommendation is to be generous in the use of your name throughout your website.

You can make your name, which is the most valuable part of your brand, significant by utilizing proper Search Engine Optimization (SEO) procedures. If your name is not included in your domain name, you can use it as a keyword throughout your site, such as on your home page, about pages, portfolio pages, and so on. Search engines will rank those pages for queries regarding your name.

SEO experts recommend you try to rank for only one keyword, or keyword phrase for each page. This understandably frustrates some artists who want to compete for numerous keywords on every page on their site. Unfortunately, it is not a valid SEO strategy. The suggested keyword density on a page is four percent. That means for every 100 words on your page where you want to optimize for your name, it should appear approximately four times.

What drives search results, and success for search engines, comes down to one word: Relevancy. Google dominates search traffic because its users trust it. They rely upon Google to deliver relevant results for their search queries. This trust increases traffic and in return gives Google the ability to sell advertising around it.

In most cases, it is best to rely on a single domain name. This suggestion means to avoid using one domain name for your art and separate domain names for your blog and/or your e-commerce site. Multiple domain names can be confusing for potential clients because they diminish the effectiveness of your marketing resources to create awareness and drive traffic, and it adds unnecessary expense to your marketing budget.

Once you have everything under one common name, then you can use subdomains to direct online traffic to specific are-

as. For example, I could set up blog.BarneyDavey.com, shop.BarneyDavey, or store.BarneyDavey.com. Google uses subdomains. You can go to analytics.Google.com or plus.Google.com. The company uses Google.com with a sub-domain to drive traffic to the specific area of their website where they want their visitors to be. You can follow its lead by taking a cue from the biggest and the best.

Don't Look Like an Amateur

As the artist, you are the brand as previously discussed, and this is true of your digital presence on the Internet. People buy from you. They are buying art from Barney Davey, the artist, not from Evergreen Art. They may soon forget Evergreen Art, but they are unlikely to forget Barney Davey when my name is on the piece of art that is hanging in their home or office.

The first thing that you do after obtaining a domain name is to create a website and then setup an e-mail address to go with your domain name. Almost all domain providers will give you a free e-mail address when you purchase your domain name. For instance, my email address is barney@barneydavey.com. Domain names and email address-es are not case-sensitive. You can use upper and lower case letters for clarity and emphasis when writing your domain or email address, but web browsers and email software programs do not read or render them as case-sensitive.

I think having a Gmail, Yahoo! or AOL address screams out, "Amateur." You already own a domain name, so it is easy to set up an e-mail address using it. I do not recommend having email forwarded to your AOL or another free email account. This only slightly masks the fact that you are still a novice when it comes to Internet marketing. Cut the ties to anything that is going to complicate your life and waste your time. Hav-ing to monitor multiple email addresses is an example. Moreo-ver, if someone sends something to your email at your domain name and you reply from your Gmail or AOL account, then the sender has two email addresses to contend with for you. This is confusing, not good and not recommended.

I know some readers have had their beloved AOL addresses since the last century and will not take this suggestion because of the inconvenience and resistance to change. Keep in mind this is about improving your professional online identity, your personal brand and your overall marketing. Nevertheless, to make the change it is worth the one-time difficulty.

As with changing domain names, switching e-mail addresses can be a lengthy process that does not happen overnight. However, if you work at it and make sure that everyone knows you are changing your e-mail address, it is something you only do once in your career. In the end, time and effort spent to make the change are in your best long-term interest. Having a domain name and email address that people can easily associate with you helps improve your branding and raises your level of professionalism. The same is true of your website, your piece of real estate on the Internet.

The importance of your digital identity to Google

Digital identity refers to an encompassing knowledge of a person's online presence. This includes your self-expression through tweets, posts, emails, blogs, websites, and other online communication. Your account names, screen names, avatars, and display names, artwork, web design, and photographs that you use, display or otherwise share on your website and blogs or on sharing sites. How your friends, favorites, and followers like, retweet, or share your content adds to your digital identity.

Google is just starting to focus intently on including your online digital identity as a search engine-ranking factor. The more it can determine who you are as you move from social media, to blog, website, online galleries and elsewhere, the higher it will rank you for content related to your name.

This goes back to Google's ongoing mission to deliver relevant quality results to its search users. In early 2013, as I write this book, the importance of establishing an online digital identity with Google is in a nascent state. Going forward, it will become increasingly more significant. Why not get started now?

It would come as no surprise to learn many artists have not established a Google+ account. If, however, they have, it is likely they are not using it for much, or are understandably confused about what value comes from participating in yet another social media site.

Establishing a Verifiable Digital Identity with Google Using Authorship Markup

To help guarantee the search results Google delivers are actually related to you, Google seeks to complete a round of verified trust between it and an author's published content.

Google Authorship Markup

For you to be involved in helping Google achieve this goal, you need to have two things:

1. A verified digital identity owned by Google that links to your published content (a Google+ profile)
2. Your published content needs to reference you as the author and link back to the verified digital identity.

This book is not intended for a lengthy technical discussion of how to achieve the above. There are numerous sources of useful information with systematic instructions, charts and videos you can use to learn how to include Google Authorship Markup as a tool to improve your online identity. Google compensates those who help it meet its goals in the form of better search rankings.

Building a website

If you must choose between starting with a website or a blog, and I recommend doing both, but build your site first. Without a website, you are a digital nobody. A professional looking and user-friendly website is of utmost importance in marketing yourself and your art. When you start building or have already constructed a site, you need to think about how to use search engine optimization (SEO) to rank as high as possible for search terms that will help people find you.

If you are a collage artist, for instance, it can be difficult to rank high for collage artists because the terms "collage" and "collage artists" are too broad. However, you can use collage artist with your name, collage artist with maybe a particular subject matter that you like to work in, or collage artist with the area or region in which you live. You should be able to rank relatively high if you match the type of art you specialize in with another term: your name, your area, or the like. That is what you want to use in your SEO efforts.

I advise you to set up a free Google Analytics account. By entering a snippet of code in the header or footer of your website, you can use the tool to determine how much traffic your site gets. In other words, is it coming from a search engine? Is it coming from a referral? Is it coming from your blog? You will also know what search terms visitors are using to find your site, what time of the day they are visiting, and where they live.

The amount of information you can get from Google Analytics is overwhelming for most people, me included. Nonetheless, you can extract particularly useful tidbits and may discover you appear in the results of searches you did not expect. As you find them, you will want to start using those words in your content so that when Google sees it, it can match the content on your site to search engine queries. This is walking your talk to match your content to keywords and phrases that ultimately will help drive your results closer to the top of the ranking for search terms specific to your content.

By understanding what content derives traffic and what does not, you can concentrate on those terms and keywords that bring you the best results. If you analyze the sites of competitors who are ranking high on search terms you value, you may find clues in the copy on their site as to why they rank higher than yours. For advanced analysis, you can use the Open Site Explorer tool. There are other useful tools to help you understand what keywords and keyword phrases searchers use to find you and your art. Strangers to you are looking for art like yours. As such, you need to work on developing and including keywords without your name included.

A powerful resource is the Google Keyword Tool; you will find the URL for it in the Resources along with the other tools

mentioned here. The Google Keyword Tool is free, but you will get results that are more robust if you sign up for a free Google Adwords account. Adwords is the financial engine that makes Google successful. It uses a pay-per-click (PPC) model to sell advertising to its customers. Wordtracker.com also has a free keyword tool. It uses results from search engines other than Google, which gives you a slightly different perspective than Google's on keyword usage relating to your business and your website.

By combining results from Google Analytics, or other free website statistics analysis services such as Statcounter or Awstats, you will amass a number of key search terms that you will need to use to optimize your site. Optimization is about content. If your site is heavily image laden with little copy, it is not properly optimized for search engines. Google recommends on its official Google Webmaster Tools site that 300 words on a page is the minimum amount of content for SEO purposes. This book's Resources section has links to Google documents for both a newbie to SEO starter guide, and a more advanced guide for experienced users. I strongly suggest you review both of them to learn more about how to optimize your site. If you are going to build it, you might as well invest in making it the best and most efficient tool possible. Regarding keywords, there is no optimal minimum or maximum number to have for your site. It will depend on how much content you have on your site. The best way to optimize it is to use one keyword or keyword phrase per page.

Should you care about search results?

Clint Watson, owner of the highly successful Fine Arts Studio Online (FASO.com) website, says SEO for artists is overrated, and I am with his opinion to some extent. Given that Clint makes his living selling websites to thousands of artists, this would seem to be a controversial position for him to take. He believes most artists' websites convert a low percentage of random search traffic to sales. I agree that most search traffic is not readily convertible to sales. Clint believes artists need to

market themselves in more personal and direct ways, such as networking and other more direct to consumer activities as discussed in previous chapters.

If sales are not forthcoming, why bother with SEO? It is a valid question. I believe you will get some sales from strangers to your site, especially if it is set up to be welcoming and if e-commerce is easy to accomplish. That is, site visitors should be able to grasp your sizes, prices, medium, shipping, and all other factors that make a buying decision quickly. Web surfers want information that is easy to comprehend. Another reason to optimize is to get email and snail mail addresses. By including an easy opt-in form, with perhaps an intriguing offer to subscribe, you make the decision to sign up easy.

Your opt-in offer could be a discount, free shipping, note-cards, or small size high-res download for your prospects to use as wallpaper, or to print and hang. Both well-known Australian artist, Hazel Dooney, and British graffiti artist, Banksy have used this offer to give high-res prints to their fans. It is a fantastic way to introduce new followers to your art. Dooney took the offer to another level by offering to sign the print the customer made if they sent it to her with a stamped return envelope.

Traffic to your website always will be crucial. It would be a mistake to forgo making sure your site is as well optimized as possible. Take the time to learn basic SEO so you can write content that will get your site ranked highly. Some of the best sites to get started learning SEO are the Google Webmaster Central blog, SEO Moz and SEO Tacklebox.

The benefits of e-commerce

I believe artists who do not have e-commerce enabled on their websites today are missing the boat. Having the ability to sell art directly from your website and/or blog is a terrific way to establish your tireless 24-hour sales system on the Internet. You may not have grand plans for selling large numbers of art over the Internet, which is okay, but by not selling any, you are missing an easy opportunity to make more money. Some peo-

ple like to buy directly from a website with no human interaction. Why discourage them? Once you get started, you might find that you have a knack for e-commerce, or that your art sells well on the Internet for a variety of reasons. There simply is no reason you should choose to share direct sales income with another distribution channel when you can drive traffic to your own site and sell directly from it.

There are numerous e-commerce platforms available. Some, like Zen Cart or Open Cart, are free, open-source software programs that can be installed on a server or shared hosting account. These programs will need to be modified to tailor them to your business, but they are free to use. OS Commerce is another e-commerce program to use on your site.

If you are using a WordPress format for your website, there are numerous WordPress e-commerce plug-ins that you can use that will help you set up an e-commerce store. These include the Marketplace theme and the Woo Commerce and WP e-Store plugins.

There are standalone e-commerce sites. 3dCart has a template-based site that I have had excellent reviews on from friends who are using it. Another popular template-based shopping site is from Volusion.com. By Googling the term, "e-commerce software," you will find many others. Naturally, some are more expensive than others are. Doing your own due diligence and research is the way to get the best results with the least aggravation.

Do-it-yourself or use a website building service

A question many artists face in the initial phases of website development is whether they should use a custom site or a built-for-artists site. If you decide to build a custom site you could hire a designer, learn html5, php and css, or teach yourself to use Adobe Dreamweaver, or any of dozens of other html editor programs to build your own custom site.

If you are in a do-it-yourself mode, you can use WordPress. WordPress is an example of an open-source content manage-

ment system (CMS). It allows you to create a truly robust website with e-commerce and attach a blog to it. The software is free. You can find thousands of free themes and plugins to customize your WordPress site. There also are premium plugins and themes that require a payment to use. WordPress has become the most popular way to create websites. Automattic, the company behind WordPress, estimates that 20% of all new websites in the U.S. are built using its software. With a growing base of more than six million users, it has a vibrant, robust community that makes getting help for how to build and maintain a WordPress site relatively easy. Due to the size of the user base, finding developers who specialize in building WordPress sites is easy, too. Check out reputation-based freelance sites such as Odesk, Guru and Elance Or, search the Internet for "freelance WordPress developer" to find a plethora of skilled designers to help you get started using this most popular software.

An alternative is to use a company like the previously mentioned, FASO.com, which stands for Fine Art Studios Online, or one of many other artist-specific website builders. Such companies specialize in building websites for visual artists. Many of them do a remarkably admirable job and provide additional marketing resources, as well. Investigate what they offer and decide if they are right for you and your business. Listings of many of the companies that specialize in building websites for artists can be found at www.gicleebusiness.com:it is a directory with nearly 500 art business related listings.

A new resource for artists is ArtSala.com from Jason Horejs, owner of Xanadu Gallery in Scottsdale, AZ. Here is how Jason describes it:

> I created ARTsala to help artists organize, catalog, share, and sell artwork. While there are various programs, apps, and websites that will help you with parts of this process, none of them do it particularly well, and worse, none of them do it all. You are left with three or four different systems to track inventory, promote, market, and manage sales. Included in the array of services is a website for our members.

Other ways to sell art online are print-on-demand and fulfillment online galleries such as Fine Art America, Red Bubble, Imagekind, Artist Rising, CafePress, Zazzle and more. They allow artists to upload their images to the site and display them in an online gallery. In addition to only viewing the art, buyers can choose an image and size to suit their needs, order it on paper or canvas, and select from several framing options. These types of online providers offer a full-service website experience for an artist.

While I think sites like this offer a superb resource for artists, I do not recommend using them exclusively; that is, I believe you still need your own website, your own space on the Internet. In addition to providing you with presence in the e-commerce–enabled portion of their sites, some also give you a free or affordable website. The best among them offer additional valuable marketing services. For instance, for an annual fee of $30, in addition to providing your own website, Fine Art America provides free email marketing, downloadable PDF sell sheets, event announcements and many other helpful tools for artists to get out the word about their work. Check the Resources section for more listings.

Some artists join and put up art on every one of these sites, as much for the back links to their own website or blog, and for the high rankings in searches for their name. If your name is one shared by many people, then the task of being found for it on top search results is difficult. Since these online galleries and art venues rank higher because of the amount of data they present, and links they have back to their site, you may find you rank higher for your name on them than your individual artist website, at least until you will have sharpened your SEO for your site.

Search engine ranking aside, I suggest actively concentrating on one or two of these sites at the most. To do more simply is too time consuming with little upside benefit over your return on focusing on the two that are most likely to yield sales results for you. View participation in others as places to gain visibility and links to your site.

Some artists question the effectiveness of including pricing on their website. I firmly believe you should show your prices. Consumers are using the Internet because they want the ease of buying online. If they must contact you by e-mail, or worse have to call you or submit a contact form, to find out how much something costs, I guarantee you are losing sales. You are not going to convince people to buy if they have to take extra steps. You have too much competition to be losing potential buyers because they do not want to call you to get prices. If you are not attaching prices because your pricing is inconsistent, then you have a different problem, one you can easily fix by committing to standardized pricing on your images across all your distribution channels. In this "We Cycle" of the Internet age, you need to be authentic and transparent, or you ultimately will lose customers and gallery support because of your inconsistencies.

User friendly is key

When it comes to a website design, whether someone is doing it for you or you are doing it yourself, the layout and functionality of the site are vastly significant. I have seen some artist websites with 10 different sloppily organized online galleries or portfolios. This forces buyers to move from one portfolio to the next, which is an easy, quick way to lose your web visitor's attention. Another sin is not providing some sort of search function on your site if your site is dense and has a large number of images on display. Having no search function makes it difficult for users to navigate the site and to find everything the artist has on display.

I recommend you set a limit of 50 pieces on your site. More than that is overwhelming. Also, show only your best pieces. If you are going to show pieces online that are also available in a brick-and-mortar gallery, do not sell them directly to the customer unless you are planning to give the gallery its full commission. Otherwise, insert a link to the gallery's website and clearly explain that this is where customers can purchase that piece. As mentioned before, transparency is a key to success

with your online marketing. Being consistent with your pricing is the fair and ethical way to treat your collectors, your galleries, and yourself. Unless desperate, why would you cut your prices? Doing so takes money out of your pocket, can devalue your art and ding your integrity. Do not make the mistake of not valuing your marketing costs in time and money. A primary reason artists undercut prices is because they fail to factor the marketing, inventory and labor costs into creating their work. If you do not respect your prices, why should anyone else?

Some galleries, such as XanaduGallery.com, have established a highly successful online presence where they represent many more artists than they could show in their brick-and-mortar shop. They never guarantee that the art will sell online, just as they cannot guarantee that the art will sell in their physical gallery. Nevertheless, because of the volume of traffic continuously driven to the site, it gives the art displayed on the site decent odds it eventually will sell. If the artwork has not sold in 90 days, Xanadu may remove it from the online gallery to keep the stock fresh. This is equivalent to rotating images in a physical gallery. Buyers are always eager to see what is new.

As an artist, you can certainly take advantage of the gallery with a large and established online presence by agreeing to have it sell your art on its website. In those situations, and to avoid any potential conflicts, you need to inquire of the online gallery management whether you can list a piece on your own site and their site at the same time. If you are any kind of prolific artist, you should have enough work to spread it around, especially if you are a print artist and offer reproductions of your work.

Many artists who sell online fail in the area of shipping, ordering and returns. You need to be abundantly clear about how you handle those elements of digital marketing. You want the experience of ordering from you as easy as possible for your customers, so when quoting a price be sure to include the cost of shipping and handling, and explain your return policy. These things are all part of the online buying experience. The easier it is to find art to buy, navigate to the checkout, and finalize the

purchase online, the likelier you are to get the sale and not have an abandoned shopping cart on your site. I cannot tell you how many times I have left a shopping cart because finding the full price, including shipping, was too complicated. I do not want to be required to give you all my contact information just to get a price. Let me give you my zip code and you provide the full price, including shipping. At that point, if the price is right and I wish to buy, I will give you all the required information to complete the purchase. When it comes to selling art, especially online, it is all about the customer experience, and not about your convenience.

I suggest you upload a video or slideshow on your blog and on your website that shows how your art is packed for shipping. You want to show someone in a clean area wearing white gloves, handling the art carefully, putting it into the shipping container, and closing it, so your customers can see how much respect you have for the art that you are shipping to them. This is just another way to present you as a high-level professional, one who respects your art and your customers. This is so easy to do. If it is a video, you can post it on YouTube where you can get more traffic and links back to your site or blog. Because YouTube ranks second only to Google for search engine traffic, you should utilize it as much as possible. Having a shipping video is just one smart way to do it.

Understanding why blogging is essential

In addition to a website, I believe a blog is tremendously beneficial and most useful for visual artists. The difference between a blog and a website can be summarized in three words: *dynamic* versus *static*. A blog is dynamic because the intention is to create a steady stream of new information. The term "blog" evolved from the term "weblog," coined to mean any web page with frequent short posts in newest first chronological order. It is a way to have an ongoing conversation with your audience and provide them with information on what you are thinking and doing. The search engines love new information, and the fresh data being current and likely more relevant, is

why blog posts tend to rank higher than website pages with similar keyword content. Websites change far less often than blogs, and as such are static.

When it comes to SEO, if you are using WordPress, then you can get the free WordPress SEO plug-in from Yoast SEO Services. It provides a truly useful, practical, and effective SEO plug-in that can help you make sure that each one of the blog posts you write is search-engine friendly. I know from personal experience if you follow just the basic techniques, you will find your post ranking higher than if you did not use it. SEO is part art and part science. Yoast unquestionably can help with the science part.

In addition to posting content that relates to user searches, the next thing you should be aware of is the importance of links, which search engines use to help them decide the sites that rank the highest. It is a bit of a popularity contest. If other sites, particularly established ones that have a higher Google page rank than your site, linked to your site on their web pages, they are giving your site their vote of confidence. It is akin to them saying, "I believe it is of value to my web visitors to know about this website; therefore, I am linking to it."

Google uses external links from similar or like businesses as one of the most important of the more than 200 algorithms employed to rank pages on a website. Do not consider abusing this policy by using shady methods to increase the number of links to your site, or even paying for links; you will not get away with it. Such tactics were used in the past to game the system. Google hires some of the smartest people on the planet, so trying to beat them with "black hat SEO tricks" is just not wise. Instead, using quality keyword content, sound SEO techniques, and appropriate links to your site will help you enormously.

There are companies that specialize in offering their paid services to help you rank for not only SEO, but also pay-per-click (PPC) advertising on Google Ad Words and other search engines. I caution you to be careful about using them. Some do a fabulous job; nearly all are expensive. If you are inclined to use one, check it out thoroughly before laying out your hard-earned money. I believe it is devilishly difficult for visual artists

to get satisfactory pay-per-click advertising results. Check to see how many PPC ads you find for individual artists competing for keywords that would work for your art business. You won't find many, and even fewer that repeatedly use PPC services. At anywhere from $1.00-$5.00 per click, it quickly gets too expensive for most artists to use PPC advertising. To make PPC work, you need to have a specialized landing page that is set up for the keyword brought by the link. The landing page also needs to be optimized to convert to sales, or at least to getting an email address from the visitor. A dollar or more per name is an expensive way to build a mailing list. Moreover, as discussed previously, most art is not a one-visit or one-call close. It takes repeat exposure to turn most lookers into buyers. For these reasons, I am not an advocate of artists using PPC advertising.

Businesses that offer these SEO and PPC services cannot fake the results they get for their clients. You can quickly check the search terms to see if the client ranks No. 1 for a particular search term. If you are going to use a paid service, check it out thoroughly. If they balk at all, refuse to do business with them. Many legitimate companies will not mind if you check their results.

While WordPress is currently the most popular platform for creating a blog and new websites, it is not the only choice. There are also free services available from Google through its BlogSpot blog program. TypePad.com offers a paid service. Tumblr.com, being more image driven, is one some artists may find attractive. (It was purchased by Yahoo in May, 2013, and it will be interesting to see what happens to it,.) Squarespace is another popular blogging software. Many top bloggers use something other than WordPress for their blogging platform. These include marketing guru, Seth Godin, who uses Typepad. Katherine Tyrrell uses Blogspot for her successful and well regarded Making a Mark blog for artists.

If you are using one service and want to switch to another, it can be difficult, but it does not have to be. I switched from TypePad to WordPress after many years because I needed more services and a wider variety of widgets and plug-ins than Typepad offers. My website, ArtPrintIssues.com, that includes

more than 500 posts and hundreds of images made importing the content into WordPress a chore. Still, in the end it was well worth it.

When it comes to blog topics, many artists think they do not have anything to say or can only write about their latest work. Nothing could be further from the truth. Check out some of the 52-blog topics I have written about [http://x.co/blogtopics]. They serve as suggestions for topics you could cover. You do not have to write about your art directly. Instead, blog about what influences your choice of subject, medium or color, how you transitioned from a former career to art, or why a particular artist's work appeals to you. Create a series of posts on similar subjects to help your readers get to know you on a more personal level. While I am not a fan of providing details on what you had for lunch, in today's "We Cycle" environment, I can see the value in being more personal.

Maybe you have an art dog who is your studio companion that you like to take pictures of and post and talk about. You can develop a fan following for your dog doing this. It could be your cat or your desert tortoise in the backyard. Maybe it is the exploits of your kids or grandkids. The idea is to bring your readers into your life in a way that is engaging, and that will keep them interested and eager to learn more. Find a story line and build on it. You do not have to make every post an update, but having a story line running through your blog is a powerful way to engage your readers. It also is an immense help in persuading your social media followers to sign up for your blog posts. The right kind of pictures and videos also offer the potential to go viral, gaining you thousands of hits on your site.

To become successful, you need to get out of your limited thinking, using ideas as suggested above. As you work on expanding your blog topic repertoire, you will discover there is a wide array of topics about which you can write. Although you need not necessarily promote your own artwork in every blog post, you will be using your posts to market yourself, your personality and your personal brand to your readers. Google Alerts is a terrific place to find items. Set it up to have it send you news, blog posts and other items relating to topics of interest.

Alternatively, you could visit a site like Art.com to see what is at the top of its list of hot-selling art and comment on that. If you are comfortable sharing your thoughts and feelings, you can pull readers in to know about you in ways they would never learn if they only ventured into a gallery where your work was displayed or visited your website.

Blogging with authenticity can be fun. You just have to open up and share. Are you sometimes amazed at the artful way the fruits and vegetables are arranged by your grocer? A quick smartphone picture will help you illustrate a story that might take you only you know where. Did you have a particularly outstanding customer experience somewhere, or a ghastly one? Is there a lesson for your readers and you from it? Can you relate it to one of Aesop's Fables? Do Dr. Seuss rhymes, sports teams changing color schemes, or the background imagery in the movie, "Lincoln," bring some intriguing, witty, funny or poignant thoughts to mind? If so, use the muse to write a post. Stuffy and dry are boring; bring life into your blogging. You can share and be compellingly intriguing without once giving up what you had for lunch.

When offering e-mail subscriptions to your blog, take advantage of really simply syndication (RSS), which automatically feeds into blog reader software. The Feedburner and Feedblitz services are the most popular ways for you to create a "feed" for your blog. These feed services let search engines and other aggregator sites know there is new content on your blog. This is pushing your content to your readers, as opposed to pulling them in with your email notices. It is crucial you connect your blog to a feed service, so it gets the widest circulation possible.

Many blog readers use a blog reader service to combine all their blog subscriptions into one convenient place to read them. Feedly, for instance, is a hugely popular way of aggregating a variety of blogs into one place so users can easily read them in one place. It has apparently become the preferred option to replace the now shuttered Google Reader. I use Feedly and find it tremendously helpful to keep up on a variety of blogs and topics that interest me.

While newsreaders such as Feedly are convenient for a blog reader, they are not good for you. That is because you want to

capture the reader's e-mail address, which you cannot do through an RSS feed. That is because your reader is subscribed to the feed service email list and not yours. The user can sign up for an RSS feed, and you will never know their identity. Therefore, I suggest that you do not prominently promote RSS feeds on your site; you should offer the option, but place it in a less noticeable part of your site. Instead, conspicuously offer visitors access to your e-mail subscription form. I advise putting your opt-in form on every page of your website and blog, and include a link to the form in every e-mail or another communication vehicle you send to potential collectors. Your blog and website are marketing tools, not marble-floored galleries; do not miss opportunities to use them to their fullest by omitting opt-in options; for the design; or other considerations.

In the sales business, the acronym ABC stands for Always Be Closing. Similarly, in the Internet marketing field, the acronym ABC means Always Be Collecting. You should use many different methods to capture e-mail addresses, but make sure you are only gathering those who have opted-in. For example, you cannot just take somebody's business card at a meeting and throw it into your e-mail list; you need to have their permission. I recommend if you take someone's business card that you write to that person and say, "As we talked about, I am adding you to my e-mail list." This accomplishes two things. First, you professionally and courteously followed up on a meeting after you exchanged business cards. Secondly, you are confirming in writing that this individual agreed to be added to your lists, both postal and email.

In addition to notices of new blog posts, you can market yourself and your work through email messages and newsletters. Use emails to notify potential customers of upcoming sales, shows or promotions. You can email to your entire list, or parts of it, as often as circumstances dictate. The more you communicate to your list, the easier it is to keep a current list, and the more individuals on your list will pay attention to your messages.

Creating a newsletter is a smooth, effective, alternative way to reach many people with multiple pieces of information. Your

newsletter should be different from your blog. It could include tips on hanging art, a list of art-related events in your local area, or a description of some of the pieces you have been working on. Include something that is a little more informative and, perhaps slightly less personal than your blog. It is just another way for you to continue to have an ongoing dialogue with your collectors and would-be collectors.

Conversely, your newsletter might contain recipes, tips on how to paint, or lessons on perspective. It could show works in progress. You can use a newsletter to run a contest for naming a new piece, or to vote on which of, say, five photographs of local areas you should target next to create a *plein air* work. You can create surveys to poll your readers on any subject. Keeping your questions short and your subject on point and entertaining are terrific ways to engage your readers. You can entice your social media followers to sign up so they can participate, too.

Check out my multi-part series on email marketing on my ArtPrintIssues.com. Enter the term "email marketing" in the search box on the right sidebar on the site to find all my posts on email marketing. Make sure your readers know there is a difference between your blog and your newsletter, and that the newsletter is only available through email subscription. Then give them a fantastic reason to sign up now!

Social media in perspective

We hear so much these days about social media and rightfully so. Who can ignore Facebook with its nearly one billion users, or Twitter with 200+ million users, or Google+, which is growing like wildfire? There is LinkedIn, Foursquare, Tumblr, YouTube, Pinterest, Instagram, Vine and more. These are all venues for communicating with potential customers. Social media, when used in conjunction with websites, blogging, e-mail, snail mail and newsletter marketing, can reach an audience far larger than attainable primarily through traditional marketing.

Still, it is necessary to understand the limitations of social media. There is a term called digital sharecropping. For instance, you do not own rights to keep the names and contact information of the people who are your friends on Facebook. If Facebook shuts down, locks you out, goes out of business, or falls out of favor, the friends you have through Facebook will be lost to you. Unless you have your own list of their email addresses, you will have no way of communicating with them. The more time you spend building relationships through Facebook, rather than on your own digital real estate on the Internet, the more you are digital sharecropping for Facebook. You are merely helping Facebook add to their billion names. Keep in mind unless you advertise, you are not their customer; you are a user. As such, Facebook can dictate in ways not possible if you were a paying member.

Speaking of paying them, in 2012 Facebook changed its algorithms so that you now only reach about 15 percent of the people on your newsfeed with any information you post on Facebook. Your only alternative is to pay for a sponsored ad that will give you up to 100 percent exposure so that your post gets into the news feeds of all your followers. (In 2014, Facebook continued to change its policies. Nothing is set in stone with how it conducts its business.) Every time Facebook changes, digital sharecropping becomes more expensive. There are numerous gurus and services that can help you harness the power of Facebook. Some of them are useful. As always, to find the right service for your business, you need to ask many questions, and do your research and due diligence. On the other hand, if you are diligent and persistent, you can learn to do it on your own. An artist friend told me she exclusively used Facebook to promote a studio sale where she sold $7,000 in art in just four hours. I am not saying that can happen for you, but it is possible. Well known, and successful artist, Natasha Wescoat, and Cory Huff, owner of the Abundant Artist website teamed together to create an outline of how Natasha uses Facebook to sell her art. Cory offers free and paid services on his website to help artists learn how to sell online.

Facebook also owns Instagram, which is a photo-sharing service. In early 2013, a class action lawsuit was launched against Instagram because of a change in terms of service that allows Instagram to claim ownership of images that you upload onto the site. Debate lingers over whether that claim is 100 percent accurate as the lawsuit is still unfolding. The point is that social media gives you exposure at a cost, which you need to consider. Another social media path, Twitter, is growing and looking for ways to offer advertising through its services. As of early 2013, I do not believe Twitter was yet a profitable service. Pinterest is another service that has encountered some controversy with regard to copyright issues and what is posted on the site.

Some remarkably good posts on ArtBizCoach.com explain how to protect your images when uploading them to Pinterest. (Check Resources for the link.) You can learn how to protect the images so that if others are going to pin your images on their Pinterest board—that you have a way of obtaining feedback and communicating with people who like your art. Pinterest has become one of the fastest growing websites ever. What is noteworthy about it is it is a visual medium and its demographics markedly skew to women web surfers. If women are your primary target, then doing the research to learn how to harness the power of Pinterest ought to be on your to-do list.

You will not find specifics on how to master various social media programs in this book. This is because I do not have the expertise to guide you on how to get the most from any of them. There are numerous books, blogs, websites and gurus who can help you develop a Facebook marketing campaign better than I ever could. Moreover, whatever I write about social media is likely to be out of date by the time you read this book. Things happen quickly in the world of social media. I do frequently post links to articles and news on social media trends and changes on my Twitter account (http://twitter.com/barneydavey).

Social Media Is Merely Electronic Networking

Putting social media in the proper perspective will help you get the most from it and spend the least amount of time on it as possible. At its best, it makes finding thousands of new connections easier than ever. At its worst, it can consume much more time than you can afford to spend on it. Commit to yourself that it is just a marketing tool. Do your best to separate hanging with family and friends on Facebook from using it and other social media for business purposes.

The purpose of social media is to meet potential buyers of your art, or to meet those who can be instrumental in helping you sell your art or connect you to contacts that can further your career. Becoming friendly and sharing with customers beyond the art business is how many artists have turned their social media contacts into buying fans of their work and advocates to get their friends and followers interested. There is no denying the power of how this works. It comes down to how willing you are to put yourself out to make those endearing digital friendships. For some, it will come more naturally than it will for others. If you are not one to use social media in this way, you may be better off maintaining a profile on the various platforms, but concentrating on areas where you can get greater results. Befriending your buyers and fans and encouraging them to promote you is a fantastic way to leverage the power of social media. Doing this is not without cost in time. You have to judge if you have the temperament, the time and are willing to commit long-term to be so engaging on social media.

As you can see, social media are not the be-all and end-all of alternative marketing. I believe artists can be successful these days without using social media if they use other marketing techniques such as blogging, websites, and e-mail. Artists should view social media solely as a secondary marketing effort that helps them generate interest and appreciation for their art, drives traffic to their blogs and websites, and which helps them collect e-mail addresses.

YouTube is a form of social media, but it is different from any other service out there. Artists, employing visual media, can use YouTube effectively. YouTube as the second largest search engine in the world, next to Google, is quite powerful. Perhaps you have noticed that YouTube videos tend to rank higher for search terms than blog posts from bloggers with high Google Page Rank figures. This is because Google puts a value on well-done YouTube videos. It wants YouTube to have an impact. It also knows users highly value and use videos to learn and be entertained. Knowing this, you should strive to find ways to incorporate videos into your blogging and website.

It is perfectly understandable if you are not interested in starring in a video, or you are a little camera shy. There are workarounds to having you face the camera to make videos. Try producing a video where you are at your easel, and your hands and work are the focal point. For about $170 on Amazon.com you can buy the lights, green background and software needed to use green screen technology. (Just search for "green screen technology" on Amazon.) Green screen technology allows you to drop any image as a background in your video. This is the same technology used by meteorologists when we see them pointing to a weather map, when the map is not actually there. So, instead of your audience seeing a featureless background, or green screen behind you, they'll see any image you pick that suits your video. For artists who are so inclined and want to do what is known as vlogging, or video-blogging, green screen tech is a boon. Vlogging is a fast growing part of the blogging community. It just means there are bloggers who primarily use videos instead of words to communicate with their friends, fans and followers. I understand some artists may not be willing to adapt to it, but for those who are and can see the value in it, there is a potential profitable return on investment in producing YouTube videos. Higher search ranking and having the potential of your video going viral is possible with vlogging.

E-mail marketing is your most affordable and useful tool

Email marketing provides an easy way to communicate directly with your prospects, partners, fans and collectors. Successful email marketing for artists is multi-faceted. Because growing your list of contact email addresses is a critical component to your art career and email marketing success, I give it in-depth coverage here.

Your email list should include:

- Clients and potential clients
- Family, friends, and fans
- Art professionals, including gallery owners, art consultants, art dealers and designers
- Business and professional contacts
- Centers of influence –mavens and connectors as described by Malcolm Gladwell in his bestseller *The Tipping Point: How Little Things Can Make a Big Difference*.

Permission Is Required – Be Respectful

Unlike postal mail, you cannot send mass email without the recipient's permission. It is illegal per the 2003 Can-Spam Act. Moreover, everyone hates spam. So just do not do it. Unless you have a trusted personal relationship with someone, do not add their name to your list no matter how promising and tempting it might be. Business cards casually collected, and email addresses found on the Internet do not give you permission to add someone's address to your email-marketing list. Despite their availability, there are no lists legal for you to purchase for your own use. You can send a single, personalized email to someone who is not on your list requesting they opt-in to your list. However, even if they reply, you cannot add them to your email marketing list without their permission. Keep in mind if you send singly addressed unsolicited emails in bulk that your domain and IP may gain what is known as a poor reputation. Every time you mark an unwanted email as

spam, the notice is forwarded to spam blocking services. If your email address or email server IP gets too many spam notices, all of your email, innocent or otherwise can be blocked. Make sure all your emails include an easy-to-use opt-out link. As a courtesy and legal requirement, email-marketing services automatically include opt-out links in the emails they send on your behalf.

Capturing email addresses requires your ongoing attention.

If you work to make it an ingrained daily habit, your list will grow fast. There are many opportunities for you to collect email addresses. Your website, blog, newsletter, email signature and social media are among the most useful. With them, you can include an enticing web form, or link to make it easy to join your list. All email marketing service providers offer web forms to enable quick, painless sign-ups to your list.

Digital Email Marketing List Building Tips:

- Add a form or link on each page of your website and posts on your blog.
- In your regular e-mails, add a link in your signature line to invite recipients to join your email-marketing list.
- When you send to your list, include both a "forward me" and a "sign up" feature in your e-newsletters, announcements, and other messages.
- Place your sign up form on your Facebook page, or use a prominent link to a hosted web form. Do the same with a link in your Twitter profile.
- If you participate in other social media, such as Pinterest or LinkedIn, do some Google searches to explore how to leverage your presence there for building your email list.

Offline Email Marketing List Building Suggestions

High visibility opportunities for growing email-marketing lists for artists are gallery shows, art shows and trade shows. Presentations and public speaking give you an easy way to collect email addresses. Take the time to tell attendees what

they will receive for subscribing so they will know what to expect from your messages. At your art fair or festival booth, place a mailing list sign-up sheet on one of your tables. Use bright signage to attract attention. Include a link to your email marketing list form on your business cards, brochures, flyers and postcards.

Use a URL shortener to make an easy-to-remember link personalized for you. I use http://x.co/barney for my Art Print Issues email-marketing list. You can create a free QR code to link to your email sign up form. There are many free online services, just search for "QR code generator" to find one. A quick response (QR) code is similar to a barcode. It uses spots instead of the bars. When you scan a QR code with your smartphone, it will load data to the phone. In this case, the web page with your email sign-up opens right on the phone. Keep your QR code handy. That way, anyone you are talking to in person can use their smartphone to scan it and immediately use your web form to sign up to your list. (You can use them online, as well.)

Give a Little, Get a Lot

It is a proven fact that if you give someone something, they are much more inclined to give back to you. Entice your email marketing list prospects with an offer or a gift. Some suggestions are exclusive discounts; advance notice on new images and products; invitations to private showing parties, free shipping; or free hanging/installation for local collectors. If you are in the print market, offer mini-prints, or note cards. Collaborate with a frame shop to offer discounts from it. You could do the same with a local restaurant looking for new customers, especially if it is one where you have your art displayed. Use your own creativity to come up with unique ways to encourage participation on your list.

Be Proactive, Take the Lead, and Enjoy the Benefits

You can offer to trade lists with other artists, or other businesses. That is, you would agree to send an email to your list promoting the frame shop's business, and they would do likewise for your art business. There are endless creative ways you can build your list. When you take personal ownership of the process, and lead in working to make a cooperative arrangement flourish, you are sure to enjoy newfound success. This will extend beyond list building to other pertinent aspects of your art career. Your mailing list does not have to be huge to be effective. It is more valuable to have a responsive list that helps you develop deeper relationships with your subscribers. Your email marketing list is mighty. A list with a few hundred names can help you pack a gallery with your best prospects at your openings. You can use your email list to drive traffic to your website, or to some event or show where your art will be exhibited.

Make Email List Building a Top Priority

Building, maintaining and regularly using your list needs to be a high priority activity. As you build your email marketing list, your contacts will grow as will your ability to influence them. Do not overlook the tremendous opportunities for expanding your successful art career by routinely using effective email marketing techniques.

One of the best ways is to do guest post blogging. This entails either writing the content yourself or hiring someone to help you write an article to go on a proposed blog that receives a lot of traffic related to your business. Your content has to be worthy and unique, and the sites you choose to submit to must be appropriate for your art and audience, so research your options thoroughly. The value of being included in a blog that has 8,000, 10,000, or 100,000 readers with accreditation links to your website are enormous, and it will help drive traffic to your site. It will raise your recognition quotient. In addition, once your first guest post is published, it will give you the credibility

to make getting other guest blogging opportunities easier. Go where your customers go, get on the same sites, groups and places where they hang out. These sites and blogs are your best prospects to approach for guest blogging opportunities.

The *Huffington Post* accepts suggestions. It only takes exclusive and well-written contributions. One way for you to gain notice from potential guest bloggers is to start reading blogs that are of interest to you and then actively post comments that contribute to the conversation on them. Become a regular commenter, and one who contributes smart comments about the content of the blog. Do not be the annoying person who writes self-serving comments with links to your site. Doing this is pointless, as a spam filter probably will delete it, or worse, you will hit the publisher's nerve with this tactic. Your mission is to add value to the blog where you are commenting. When you do it on a regular basis, the blog's publisher will take notice. This gives you a much better chance of securing a guest blog spot than if you just ship something off to them when they have never heard of you.

I regularly receive unsolicited email with requests to trade links, or suggestions for some unrelated topic for guest posts, or impersonal submissions such as one that came to my Inbox recently. It had "Story Idea" in the subject line. There were two files attached, a Word document and a zip file. There was no mention of my name, recognition that the sender knew anything about my blog, or any personalization at all. This email immediately went to my Spam filter. Had it been respectful with a polite request, I most likely would have replied. I do not want to offend my followers, but I also have zero tolerance for lame marketers trying to get my attention. With that story in mind, you should supply well-documented on-topic ideas for blog posts, or posts ready for publication. Naturally, you want your copy to be flawless. Having your copy professionally proofread is a wise action. If your intended blog publisher rejects or ignores you, it is fair game to take it somewhere else, but do not simultaneously offer the same story or post to more than one outlet. That is a way to kill your reputation and make

sure that you never get an opportunity to be a guest blogger anywhere else.

Do-It-Yourself Email Marketing For Artists Does Not Pay

Email marketing is not something you want to DIY (Do-it-yourself). Although you can find software packages to do it on your own that will manage an email list and send bulk mailings from your own server, it is not advisable. For the time, expense, results and legality, email marketing for artists is not an appropriate fit as a DIY program.

Here are five reasons to avoid DIY bulk mail:

1. To begin, you must keep your domain name and IP address from having spam-blocking services blacklist them. If that happens, you will find all of your emails, both individual messages and mass messages, blocked. Your Internet Service Provider (ISP) also may cut off your email service.

2. Not all your subscribers receive email in HTML format, which allows for images, text formatting, background colors, and so forth. Your email marketing service will give you the option to create both HTML and text formats. It senses the type your subscriber uses, then it delivers the correct version. Sending an HTML version to a text editor looks like crap; don't do it. Email marketing services provide templates you can easily customize, or build your own using html.

3. You must offer your subscribers an automated process to opt-out of receiving more email. It's both a legal and considerate action. Your email marketing service will provide a system that automatically removes any requests to opt out of your list. This helps keep your domain and IP address white-listed with spam-blocking services. It also keeps you in compliance with the 2003 Can-Spam Act.

4. Checking the success of your campaign is crucial. Your email marketing services provider will help you track

how many messages were opened, how many sub-scribers clicked on links in the messages and which ones opened their message. Most will give you a way to make A/B split testing. This allows you to improve your marketing messages and make them more efficient.

5. Your email marketing service automatically includes opt-in forms, buttons and links. These will help you expand and manage your list with little routine involvement from you.

For success in your art marketing efforts, you need an effective email marketing program. Fortunately, there are many affordable and free online email marketing services available. There are so many options it makes choosing the best one for you a challenge. Virtually all e-mail marketing service companies offer affordable, easy-to-use bulk e-mail services. You can use them to communicate with collectors, fans, dealers and prospects with a professional and legal system.

There are both free and paid email marketing services for artists available. Paid email marketing service providers base their rates on the number of e-mail addresses on your mailing list. The average plan runs between $10 and $20 a month for a list size of up to 500 with unlimited mailings within a given month. Compared to the cheapest bulk direct mail rates, email marketing is a bargain. You cannot do better than free with email marketing services. The two I recommend are MadMimi.com and FineArtAmerica.com. Madmimi offers a free plan for up to 2,500 addresses. You can send up to 12,500 emails using it every month.

FineArtAmerica.com, (FAA) as previously mentioned, is a free online marketing, print-on-demand and complete fulfillment resource for visual artists. The FAA service is particularly useful to help you promote your work listed in your online gallery and on the free website that is also available for those who pay the nominal $30 per year upgrade fee. With its easy-to-use formatting, it is an effective way to help you promote your work on the FAA site. Using Mail Chimp and FAA's email marketing services, gives you additional powerful features. These include list building services such as opt-in forms, buttons and

links. You can also use paid services, such as Madmimi, to send auto-responder and drip campaigns. These are easy ways to send an automatic single response, or a series of timed responses to your subscribers.

I realize it is tempting to go with the free service. However, I suggest you don't because you lose the ability to create automated responses and drip campaigns, which are powerful features you want to start using right away.

Paid Email Marketing Services

If pass on my advice to go with a paid service right away and you are lucky and diligent enough to build your list beyond 2,500 names, you can upgrade to a paid service from Madmimi. Some other paid providers to consider including:

- Mail Chimp (paid for lists larger than 2,000 names)
- Constant Contact
- iContact
- Aweber
- Campaigner

The above listings represent just a sampling of the popular email marketing services. Ask around in your art marketing circles, or do your own online research to find even more services. It is best to settle on the one you think will work for you. Having to import a subscriber file from one service to another can present problems.

Effective design in email marketing is essential

Using email marketing services to drive traffic, create interest and make sales is a cost-effective and efficient way to promote your business and develop a growing, loyal fan base. Understanding and using email marketing design techniques increases your readers' interest. Effective design will keep them reading your messages. We have covered the importance of building your email marketing list and options for different email marketing services. Email newsletter design is yet another essential component.

Start with a Pre-header

A pre-header is the first line of copy above the body of your email. It displays in some email programs, such as Outlook, and in most mobile email users. A well-written one will improve your open rate. Email open rates differ. (An open rate is the percentage of subscribers who click on and open your email.) Unfortunately, you will not have every subscriber opening and clicking through to read your email. Your email service will provide you with statistics and show you exactly which subscriber opened your message. Some subscribers will open, but not read the entire contents. As a secondary subject line, a good email marketing pre-header will enhance the open rate and click-through rate for your email marketing messages. It appears just after the subject line in an Inbox. For your readers, it briefly summarizes what the email is about before they open it.

Use headlines and images

Use headlines to section off content within your email. Identify them with html header tags, such as h1, h2, and h3, to break up blocks of text. Many readers are skimmers. You can give them the essence of what your email message contains by moving them through the copy with headlines. Keep your headlines short, informative and punchy. Sometimes it makes visual sense to use a headline that relates to the second block of text below it, rather than the first. You will not lose readers by doing this. On the contrary, if the headline is compelling, it will intrigue subscribers enough to keep them reading in order to discover the copy to which the headline refers.

In email marketing for artists, pictures help tell your story visually. Images brighten your copy. Images help readers understand what you are saying in your email marketing message. Always use the Alt-tag option on your images. ALT attribute text is the short line of copy that shows if a viewer hovers over the image. It also displays if your recipient's default is set not to display images in their browser or mobile device. Alt-tags are strong selling tools in email marketing for

artists. If you do not change the picture default name it might show something like, DSC-12115.jpg, which is a tiresome and useless default name from your digital camera. With image alt-tags, you add context and have a chance to tell your story more elaborately. Make your tag descriptive or a call to action, or both. "Get 25% off all images from the Waterfront Series until (expiration date)." Make your images the right size for your content. Don't use large images directly from your camera or smartphone. Use Photoshop, or some other photo editing software to compress the image for web use. Pixlr.com is an online slimmed down program similar to Photoshop. Gimp is freeware that is similar to Photoshop.

Content Blocks

Use short content blocks. This helps your design work for the short attention span of most email readers. Try to use only two or three short sentences in each block. To make your copy easier to read use bullet points and numbered items. They will increase your results.

Call to Action and Links

Your email marketing newsletter is a sales and a promotional tool. While it does not hurt to be friendly and sociable, that is not the point. Make sure you have a Call to Action designated for your newsletter. Yours might be:

- Announce a Special Offer
- Invite to a Show or Exhibit
- Purchase an Artwork Directly from You
- Invite to a Gallery Opening
- Take a Survey

Your Call to Action can be a hyperlinked image, or a text link, or both. Use text links to promote your readers' attention, or to direct them to something you are writing about. For instance, if you visited a local museum, link to it in the copy about it. Alternatively, if you have an image of an artwork for sale on your website, link to the order page, or to a page on

your print-on-demand fulfillment site, such as Fine Art America.

Design Elements and Navigation

If you pay attention, you can observe the current trend using more white space in graphic design, including email marketing. See how grocery flyers these days are less crowded with items. Most fonts are flat, without shadows, bevels and other Photoshop tricks. Make sure you use fonts that are simple and easy-to-read. Use personalization sparingly and where appropriate. Incorporating a person's name makes your copy friendlier, unless it is overused; then it becomes sales-y, which is a big turnoff. In most cases, just use the first name, or occasionally both first and last names. People never want to see their address or phone number in your email marketing copy. Navigation is a useful design tool. If you have various sections, or your text is lengthy, then use the page navigation as part of your email marketing newsletter design. Navigation helps your readers quickly jump to the part they want to read. Anchor text is another way to help your readers navigate your newsletter.

In email marketing for artists, content is king

Content is key to email marketing for artists' success. I believe email marketing for artists is necessary for any comprehensive strategy designed to develop a successful art career. To be effective, your email marketing newsletters and messages need new, stimulating, and relevant content. As with all successful endeavors, planning and focus are keys to success. Organization and preparation are how to enjoy more success and have less stress from your marketing efforts. Email marketing for artists is the same as for any other business. When the deadline to start writing comes, having your content ready is how to reduce anxiety over how long it takes to compose your article. Rushing to find last minute news and ideas for your content creates worry and wastes time and money.

Create content keeping systems.

Evernote.com easily is the best way for clipping online content. It helps you quickly and easily capture and organize anything you find online. Microsoft One Note also is a convenient info organization tool. You can print any document from your computer to it, and you can copy and paste information from the Internet into it. Another method is the old school paper method, but if it works for you, keeping a physical folder with ideas for content is better than nothing. The goal for your email marketing strategy is straightforward. Being organized helps you engage your subscribers with content that keeps them involved and excited. You want subscribers to anticipate receiving your email newsletters, and to enjoy your content.

Content is about you, just not all about you.

Use a mix of information about you and your art, including noteworthy news, which could be either personal or professional. Write about your current projects, events, sales, and promotions along with other enticing tidbits of useful, entertaining items of interest. Of course, your email marketing for artists content needs to be about you. Nevertheless, the more you incorporate content not specific to you that both interests and intrigues your subscribers, the more your readers will be eager to receive and read your messages.

Here are 10 suggestions for producing innovative and relevant content:

1. Video content is powerful. If you are already creating short videos to help you stand out with your audience, put them in your newsletter. The easy way is to insert a tightly cropped screenshot image from the video. Then link the image to the streaming service, such as YouTube, where it is uploaded. This avoids the problem of email programs filtering embedded videos.

2. Special Deals. Provide exclusive invitations or offers only available to newsletter subscribers. Make it pay for your subscribers when they subscribe to your email.

3. Ongoing Useful Content. Add a regular "Tips for Art Collectors" as a fun, ongoing component of your newsletter. A few suggestions are how to hang art; how to care for art; the placement of art; framing or reframing art; storage; shipping; consignment; how to use the secondary art market; or the best way to spend one hour at your favorite museum.

4. Guest posters. They will add a different perspective or expertise to keep your art marketing content stimulating. These guests could include other artists, a picture framer, a museum curator, another art collector, or the organizer of the show where you exhibit. If you find the perfect post somewhere, you can contact the publisher for permission to reprint the post. Try getting one of your collectors to write a guest post for you.

5. Relevant news rules. Use news about you, your local art community, or the whole art community to involve your readers. Ask for feedback. Set up alerts on Google Alerts for topics you believe would attract your readers.

6. Resources for ideas are abundant. Keep up on news, trends, events and opinions. The New York Times Art & Design and Huff Post Arts pages are examples of productive resources for your email marketing story ideas, as are many blogs found on the Alltop.com art section.

7. Keep up with your competition. When it comes to email marketing for artists, it is necessary, if not crucial, to know what other artists are doing. If you find something useful, you can link to it, or write your own art marketing content to add your opinion and perspective. If it is content helpful to you, for instance, funding arts in education, your new post citing the original post will extend the messages and keep the drumbeat going. Notify the original author to let them know you linked to their copy; it might be the cause for a prized link back to your content.

8. Spend Time in the same online spots as your buyers. Use these sources for research first and communication second. Follow your buyers to find the groups and communities where they hang out. See what topics are trending within those groups. Perhaps there is a charity or activity you were not aware of that is relevant to them. Never be a phony. However, if you are like-minded feature their interests in your art marketing newsletter, or contribute to their cause and recommend it in your newsletter.

9. Get personal. For some of us, it is easy to share stories from our own lives. Do not despair if that is not you. Draw parallels from third party examples. It could be anything that inspires you. If you learned a lesson from the classics, or were deeply moved from seeing or reading Les Misérables or Anna Karenina, relate how your life, art, or business was affected by it. Write about how these influences informed or inspired your newest works. Exhibits in museums might have done the same. Sharing at this level is compelling, especially when you include your art and creative process.

10. Use keyword and trend tools. They help you get inside the thoughts of your best customers and prospects. Use the Google Adwords Keywords and the Wordtracker Free Keyword tools to create a list of the way your customers search to find art and artists. Layer your research using the Google Trends tool. (Check the Resources section for links to tools mentioned here.) The point is when you know what your collectors and prospects are looking and searching for, you can build your content around their interests. This is much more efficient than guessing or exclusively publishing about your interests, although it is likely you will find much common ground between your subscribers and yourself beyond your work. Magic in content occurs when that happens.

Bonus Point: There is a wealth of information from search engines.

Doing your own research for art marketing newsletter ideas and suggestions will result in many more helpful suggestions you can use to make your newsletter copy sparkle. Just as with making art, the more you do it, the more your expertise will improve. You may find inspiration for subject matter for your art as a side benefit of your research. The more you dig, the more you will find a myriad of items you can include in your newsletter. Never forget that the primary purpose of email marketing for artists is to spur interest in you and your art and lead to sales. Make sure you have links to pages where your readers can find your art and buy it online.

Make a schedule and stick to it. Commit to sending your newsletter at least monthly. Any less than that and your list will become stale, and your readers' interest will wane. It is too precious to let that happen. The basics of successful email marketing newsletter design will improve your email marketing campaign effectiveness. Learn to incorporate them into your email marketing efforts, and you will begin to see growing interest in your newsletter. This will translate into more conversions to sales, better open and click rates for your newsletter.

Online galleries and art selling venues

The granddaddy of online art sales is eBay. Over the years, it has gone in and out of favor with artists seeking to sell their work online. As a result, it lost its once dominant position in the market. To be fair, it also faced increasing competition from dozens, if not hundreds of competing sites exclusively focused on selling art online, both originals and prints. Unlike the print and fulfillment sites mentioned earlier, eBay requires the seller to ship art once it sells on its site. Since eBay's inception, thousands of other sites have popped up attempting to sell art online. It is nearly impossible to keep up with every online venue trying to build a relationship with art buyers.

With annual sales in the $20+ million range, sister companies Art.com and Allposters.com combine to be the largest seller of art online. Relatively low-priced prints and available framing constitute the bulk of the sales. Although these sites do not accept submissions, independent artists can use their ArtistRising.com site to promote their work. Recently, the company began integrating relevant results from Artist Rising into Art.com.

For prestige purposes, artists can consider joining SaatchOnline.com. Here is how it describes itself:

> *Launched in 2006 by the internationally renowned Saatchi Gallery in London, Saatchi Online aims to continue the gallery's legacy of promoting new, contemporary talent and bringing great art to a wide audience. Saatchi Online is an online gallery that enables artists to exhibit, promote and sell art online, and to find collectors all over the world for their work.*

Another example is XanaduGallery.com, which you have read about in other chapters. It does jury submissions to its site but has no fees and only charges a 20% commission when a work sells. There are too many online sites for artists to register their work and do their own fulfillment to list or discuss in this book. If you are interested in pursuing them, do enough research that you do not waste your time or expose yourself to problems. Sometimes these sites can be extremely useful in helping you sell your work, or they can be a dud. Getting referrals from other artists makes your research easier. Check out WetCanvas.com for its Internet Sales Strategies forum. It provides lively discussions about websites for artists to sell online.

Online marketing on its own is much weaker than when combined with offline marketing. When you combine both traditional and online marketing and focus them on the most pivotal events and activities relating to your art business, you create a powerful synergy. In the next chapter, we will discuss how to harness these things together to create the greatest amount of marketing momentum in your art career.

Synergistic Guerrilla Marketing

The word synergy means the interaction of two or more entities to produce a result that is greater than the sum of their individual outcomes. Put another way, it is where the sum of the parts is greater than the whole. In the context of organizational behavior, synergy is the ability of a group to outperform even its best individual member. The idea is to concentrate all your marketing on a single goal. That way, you will get much more mileage out of each marketing technique than using one method at a time without overlaying and focusing each on a common goal.

Making the most of your time

Before we cover this in detail, let's discuss the pertinent topic of time management techniques and how they relate to your available time. It is impossible to carry out a successful marketing campaign, meet all your creative objectives, and get all your studio work done unless you develop and utilize time management skills.

If you are reading this and you are like me (formerly for many years) in that you have a full-time job to provide benefits and income while simultaneously building a second career, you must use time management to get things done. To be fair, the

same is true for all full-time professional artists in that their time is also limited.

Before working on time management skills and setting up a program that will help you calculate how much time you have and what to do with it, you need to review those goals that we talked about in Chapter Two. It is most urgent that you know exactly what you want from your career and that you are comfortable with your choices. With those goals in mind, then, you can begin to put together a marketing plan that will help you achieve your objectives, much like building a brick wall one brick at a time.

By concentrating on and organizing your goals, you will achieve one task and then another. It is like putting mortar between the bricks as you add one interlocking layer upon another until your wall has a solid foundation built to rise and last. Without a goal to know in what direction to point your wall, and how high to build it, you have no clue about what to do first. Speaking of firsts, a hero of mine is Stephen Covey. He is the author of the bestselling book, *The 7 Habits of Highly Effective People.* One of those seven habits is "first things first." What Covey means is you should do the most important things first. Do not leave them behind. Do not be distracted by things that seem important but actually are not. Have the discipline to stay on course. Similarly, Covey challenges his readers to "keep the main thing the main thing."

There is another author by the name of David Allen, who has written a book called *Getting Things Done.* It has been on the Amazon "Time Management "category bestseller list since 2002 and is still No. 1 on the list in2014. In it, Allen shares methods that you can use to create what he calls stress-free performance. Briefly, you need to put a system together in order to know what you want to get done. Commit it to paper, or other tool, to take it off your mind until you need to address it. Then you can begin to tackle your goals systematically. His contention is we are far less productive when we worry about the things that we might not be getting done. By freeing your mind in this manner, and having a system in place to prioritize your "to-do" lists, you will be more productive in the end.

Another bestselling author I follow is Michael Hyatt, who penned *Platform: How to get Noticed in a Noisy World*. He is also prolific blogger writing on topics such as leadership, productivity, marketing and book publishing. Hyatt is remarkably insightful and thorough in his personal and business life. He admitted to his readers that he knew he was not getting to everything he needed to get done, and decided to do something about it. His method was to create what he called My Ideal Week. A link to his blog post, which includes an Excel spreadsheet that you can download, is in the Resources section of this book. The spreadsheet is an exact copy of what Hyatt uses to help him manage his time.

Hyatt understands that, as with everyone else, he has only 168 hours each week in which to accomplish his goals. When we realize no one has even one extra minute, it becomes obvious to be most effective, to get the most done in our lives, we must make the most of our time. Hyatt began by blocking out every minute of his 168 weekly hours. He accounted for every minute including blocks for sleeping, rising, eating, working out, answering and sending email, dinner with his wife, meeting with people, taking a nap, mentoring, going to church, and so forth. By successfully blocking out his time, he began to notice there were gaps where he was not utilizing his time wisely, or where he was spending too much time on things that were not his top priority, or "main thing."

The exercise allowed him to focus on keeping first things first and significantly ramp up his productivity. You can do the same thing. Use Hyatt's spreadsheet to set up your own Ideal Week. You may be surprised at where your time goes if you plot it for a few days, or a week. Find the gaps and the wasted minutes and hours and use them to get more time into the priority items you decided upon in your goal setting exercises.

An excellent way to decide and prioritize your goals is to use brainstorming. I positively encourage you to conduct brainstorming sessions with yourself, your staff, and your spouse or partner on a regular basis. You get the best thinking from the people who are most valuable to you. If you have a mentor or a coach, include them in this exercise. There are

some incredible tools to help you brainstorm. Mindmeister.com is one, another is Thebrain.com; both offer free mind mapping tools. You can search the Internet for mind mapping tools and find others. With a brainstorming session and a mind-mapping tool, you can start throwing out ideas, beneficial or lousy, and writing them down. Then you need to start connecting the dots between the smartest ideas and deleting those that do not make sense. Work at refining this technique and you will soon be able to identify what you want from your career. An excellent resource for creating exercises that help you look at problems and opportunities in new ways is *Cracking Creativity: The Secrets of Creative Genius*, a book by Michael Michalko.

Project Goals Set the Stage for Success

You can achieve so many things with brainstorming tools and exercises. For the purposes of this book and for moving you to succeed at achieving your career goals, use them to help you determine the best course of action to take to set clear objectives for getting there. With those objectives in mind, you can create what I call project goals. These are overarching goals for an entire year and beyond. They need to be based on the full spectrum of marketing activities you plan to employ over the next 12 months on a rolling 12-month basis. While it is expected and encouraged to have longer-range goals than what will happen in the next 12 months, your project goals should fit inside that running annual calendar. Planning in this way helps you stay focused on what is paramount now.

To re-emphasize, you should have goals with a view for at least five, if not the next 10 years, or longer. Where does your vision for your career take you in five years, and in ten years? To get there, you need to have and implement incremental goals. What do you expect your art career to look like in three years? The closer you get to real time, the more granular your goals need to be. Going the other way, what are your plans for tomorrow, for next week, for the next month, and for the next quarter? As you get further out, the broader the goals become.

Project goals are a perfect use of guerrilla marketing techniques

Active guerrilla marketing is about maximizing the available resources you possess. What you want to do with synergistic marketing is to put all resources to use on a single point of inflection. You may not have a sizable marketing budget, but you make up for it by marshaling your resources, so they hit at the same time. When you use everything you have to create waves of marketing messages that all have the same intent, you strengthen and multiply the power of each component.

You will do this by focusing your efforts on the two or three best annual options you have for selling lots of your art in a short time. You are looking to avoid working on trivial events with little chances of selling many pieces of art in a compressed time. You will learn to let those temptations pass no matter how enticing they might seem at the time. A friend calls these things "Bright Shiny Objects" – stay away from them. Guerrilla marketing is about maintaining your focus on getting those things you have deemed indispensable done, and then wisely using all your resources to make sure it happens.

Although you do not need to know what your day-to-day plans will be in 36 months from now, you do need to have a handle on key activities for the coming 12 months. You need to make monthly adjustments that bring the new rolling 12-month calendar into focus. What new activities do you have planned for in the 12th month of the new calendar? Are there events, items and actions taking place then that need to be started this month, or sometime in the preceding eleven months? Tackling your projects in this way helps keep you from feeling overwhelmed about future events and activities. It is similar to David Allen's thoughts about to-do lists. That is if you know you have an art show in 18 months that will get its full marketing in due time, you do not stress about it now.

Before you can commit to scheduling marketing activities and plans, you need to take a number of things into consideration. It is essential to decide how much you can realistically handle at any given time. To get a handle on learning where

you are and what your capacity is, you need to assess your available resources in these categories:

- How much time do you have for marketing?
- How much money do you have for marketing?
- Do you have staff or other assistance, such as a virtual assistant to help you, and what are they capable of doing for you?

Having this information in hand will allow you to make smart, informed decisions about how many projects you can undertake in any given 12-month period. I believe no more than three major projects, not running concurrently, is plenty for artists just getting started with project planning. Take no shame if you choose to target one or two projects at first. Only you can know what you are capable of doing. I believe it is better to be conservative and initially err on the low side. You can always ramp up to take on more projects if you find you have more capacity than you initially thought. However, if you begin by overloading yourself and your staff, you may dig a hole that is hard to escape.

To reiterate, for best results, I recommend you limit yourself to no more than three projects if you run a small, one-person shop, or are new to the whole idea of using coordinated marketing plans. Planning and executing three marketing activities in one year is a commendable achievement. This will allow you to look forward to doing more as your comfort level and expertise grow with your success.

If you have the staff, experience and other resources, taking on more is up to you. It seems that tackling more than six major projects in a year's time is too much for nearly any self-representing artist, no matter how large their staff and resources. Ultimately, your budget and available assets will determine how many projects you can juggle in any 12-month period.

Identifying project goals – Matching Career Vision

Project goals are what you have targeted to create buzz and activity to sell your work. They typically are pivotal events,

such as a prestigious show in nine months, 12 months, or 18 months. Alternatively, you may want to have an enormous holiday blowout sale in November of next year. Perhaps you are running a Christmas in July summer sale, or your guild or art association will hold its annual affair that you cannot miss. Project goals can be any of the numerous opportunities you have to work on promoting your works and selling your art. They will be the ones that get your full attention, for budget, marketing effort and time. Be extremely cautious about adding in those seemingly effortless projects as they nearly always take twice the time and twice the cost as you initially expected.

Take time to make sure your project goals advance your career goals

Your project goals should mesh with your vision of how you want your career to unfold. Setting up to sell more art more efficiently is laudable, but by itself, it lacks urgency if the project goal does not also advance your larger career goal. Ask yourself if the project goal enhances your career goal. Your career goal can be to have 100+ collectors, or to be in x number galleries, in a museum, become financially independent, put your kids through college. It can be anything else remotely realistic given your talent, desire, determination and resources.

Work at setting realistic, achievable project goals and above all, make them meaningful goals worth pursuing. If they are not meaningful goals, it becomes easy to fall off the pace and your goals will never come to fruition. Synergistic guerrilla marketing is about shaping your planned productivity around targeted events and then looking at all of the tools that are available to you. You choose from both traditional and digital techniques, and implement those that will provide you with the highest rate of return. Keep in mind that it is imperative for you to carry out these plans effectively, and for this, you will need production goals to match your project goals. There is no point in ramping up your marketing and project goals if you will not have enough work to sell.

Getting to the right decision on project goals can be painful. If you have pet projects that are marginal, or some that you have an emotional or other attachment to, you may have to let them go if they lack potential to further your career. It's career triage. Choose the marketing events that will help you further your goals. You are running a business. As such, you need to make the tough decisions about where you will invest your time and money. Your top decisions are how many project goals to tackle in the next 12 months, and which ones to target.

As previously mentioned, there is no shame in taking on less than three projects for the coming year. It all depends on your available resources. If you are working towards building a full-time art career around working at a demanding full-time job, you may need to focus on one or two key project goals for the year. Whatever number of projects you select; successfully getting the first one under your belt will be enormously fulfilling, informative, and motivating for subsequent ones.

Production goals have to fit project goals.

To understand your production needs, start with what you sell on a monthly basis on average. This estimate will vary widely for artists because of the nature of how art gets to market in the first place. You already know there is no rule of thumb. Regardless, if you have been selling your work for a while, you will be able to come up with a projected number of pieces that you can produce annually. With that annual figure in mind, you can use your own guesstimate of how many additional pieces you will need for your project goals. You also should know approximately how long it takes you to create each artwork. The point of this production evaluation and analysis is to determine how much time in your Ideal Week you need to spend making art. It is a given that the hourly requirements will not be the same week in and out. You may have a seasonal business, or any other number of mitigating circumstances that affect your workflow. Nonetheless, the better you can allocate the necessary time to maintain a sane production

schedule, the more time you have for marketing your art and the less stress you have in your life.

Planning your activities

With project goals and production goals set for the next 12 months, you can begin to go about creating a list of necessary marketing activities to achieve these goals. This is where your time management skills will help you. As you go about performing various tasks, whether it is making a piece of art, writing a blog post or designing a postcard, take note of the amount of time these functions take. Having an estimate of how much time each task requires allows you to allocate the time to get it done properly. Having accurate estimates of the time needed is what will give you greater control over your time. It will help you make smart decisions about your production and your project planning.

You might find you need to cut back on how many pieces you will need to make this year, or that you have time to work on more than you initially thought. The same is true for your marketing. Taking on what you can realistically accomplish is how you stay motivated and excited about your future. Overwhelming yourself due to faulty resource evaluation, or pushing your career beyond your ability to keep pace, can run you into a hard to shake rut.

Your success depends on you having the discipline to stay the course by completing all the necessary tasks so that you create an overlaying synergy with your marketing. First you need an effective guerrilla marketing plan. Use brainstorming tools to define your target and to-do lists to help you stay on target. An online tool I use and highly recommend is Todoist.com, which you can also get as an app for your Android or iPhone. It also works with Outlook to help you set up plans and timelines for your tasks. You can do the same thing with a piece of paper and a pen; whatever works best for you is, by definition, the best tool. Find a way to track your projects, so you know what needs to be done, and by when.

For example, let's say you are planning a studio tour twelve months from now. It's not too early to start thinking about ways to attract the largest number of people and garner the most publicity for your marketing dollar. Your procedures should include incorporating as many of the marketing tools in the following list, which, while comprehensive, may not encompass every item you will put to work in your marketing plans:

- Website
- Blog
- Newsletter
- E-commerce
- Email blast
- Postal mailings
- Postcard mailings
- Gallery marketing
- Social Media
- Advertising
- Referrals
- Networking
- Press releases
- Publicity
- Advertising
- Affinity marketing
- Affiliate marketing
- Broadcast media
- Podcasts
- Guest blogging
- Event marketing

It is all in the touch

It is probable you do not have the resources to use all these tools on every project goal, or use them fully. An efficient plan will use as many tools as you can reasonably work into your schedule. Active guerrilla marketing is about repeat exposures, or touches, on your target audience. It is estimated that it

takes seven to ten, or more, contacts to move a buyer through the AIDA (attention, interest, desire and action) continuum. It takes repeat exposure to sell art away from resort locations, cruise ships, and other such locations where both decision makers are present and in a typically relaxed and open to buy frame of mind. One-off marketing with no other supporting marketing is the opposite of synergistic marketing. It is usually a waste of your time and effort and unworthy of any true guerrilla.

The multiplying effect of synergistic marketing

The purpose of synergistic guerrilla marketing is to take all your available marketing tools and focus them on your project goals. In doing this, you focus using each tool on a single project with the same goal. In effect, you are leveraging each component of your marketing to focus it on helping you get the most interest, traffic and sales for your chosen event. The saying about the sum of the parts being greater than the sum of the whole applies here. Guerrillas effectively beat larger, better-equipped forces by applying rules such as these. More simply put, synergistic guerrilla marketing gets you the most bang for your buck.

This kind of marketing will only give you the best results if you do proper planning to pull it off. It has to be organized and applied at just the right time. Since each aspect or tool has its own timeline with some requiring longer lead times to complete than others do, you need to understand what steps are entailed to finalize each marketing task. You also need to have a clear idea of how much lead time each task needs. You will repeat some tasks multiple times leading up to your event. For example, your coordinated campaign could run over a 90- or 60-day period. It could include three email blasts, a guest blog or two, one or two newsletters, two or three postcard mailings, two press releases, and possibly several ads in appropriate advertising vehicles. I know I previously downplayed print advertising, but that is a general statement. If you have a budget and can include it, consider carefully adding it to your schedule.

In addition make sure you work the publication for all valued added it offers.

Of course, you will involve social media platforms with numerous tweets, Facebook mentions and so forth. Perhaps you can get some of your real life or digital friends to help you by sharing tweets and posts. Additionally, you also might try to plan for getting publicity where you ideally have local media doing some kind of profile about you and your event. This would be a terrific way to top off your other guerrilla marketing activities.

Project planning is the heart of synergistic guerrilla marketing

Project planning requires the use of some kind of tool to execute successfully. At the bare minimum, a spreadsheet and a calendar with a reminder system to highlight what needs to be done on what day; this will keep you on track. Of course, no amount of tools will help if you do not have the discipline to complete the task, and keep moving to the next. This is where a coach, a mastermind group, or an accountability partner may be invaluable to you.

For this system to work, you need to look at your to-do list daily, your calendar at least once a week, maybe as Michael Hyatt does on Sunday night so that he knows, on each day of the following week, he will be doing x and y. It allows him to get mentally motivated and avoid distractions. If other obligations interfere with his plans, you do as Hyatt does and decide which is more relevant to do at that time.

The point is to record your list of objectives and timelines so you can see all of your tasks, when they need to start and when they need to end. You will find some overlap, but if you plan your time wisely and not overload yourself with too much to do at any one time, you can get all of these things done in an efficient manner. When you begin to execute in that way you are going to feel so much power in terms of what you are actually capable of doing, it will amaze you. Take the time to think about your goals for art creation and the marketing chal-

lenges for the coming year. Whether it is a holiday sale or gallery opening, or introducing a new line of images, the fact that you have decided to explore planning for it far enough in advance can help your marketing become more effortless.

Planning makes perfect

Your first round of planning should be brainstorming about what your goals and projects are. Then move on to which tools you will use, how you will use them and how often you will use them. Once you refine your plans and decisions, you can move into thinking about timelines. Find the type of promotion you want to generate, and which media outlets can provide helpful coverage. Your plan should include what publications and media people, bloggers and journalists you believe would consider featuring you—and what you need to do to get their attention. Publicity may offer the strongest pull due to the implied endorsement a disinterested, but notable, third party media brings to you. As such, your lead times on planning and strategizing for publicity might take 12 months. Some magazines work with editorial deadlines that are five months in advance. Get their media kits and then work on getting on the radar of your best media prospects. If you have a budget, a public relations person or publicist who already has contacts can be valuable to you.

You need to have your press releases, articles, or publicity column submissions ready to meet targeted media deadlines. Some media offer free publicity presentations for events, seasons, columns, and so forth. Part of your job is realizing they exist and when and how to use them. Just know they are inflexible on their deadlines, which means to be considered and included you must know them and then plan backwards for how much time you need to create your submission to them. To make it work, you have to become a knowledgeable student of the deadlines and material requirements for different kinds of media you wish to use. These are things a partner, or virtual assistant, can do.

To stay organized and on track, I believe you need some sort of project management system. You can use a spreadsheet, a whiteboard or paper calendar, project planning software, or task/to-do software such as Todoist.com, which is what I use. Here is a link to a Lifehacker.com post on how to use Google Calendar for project management: http://lifehacker.com/5918676/how-to-use-google-calendar-as-a-project-management-tool. It will require an investment in your time. Another free useful app is Insightly.com. It combines a CRM, which is a contact management system, a task manager and a project manager. This app can be integrated with Google calendar and Gmail. My barneydavey.com email uses Google apps because it integrates with all the other free productivity tools Google offers. I have just begun evaluating Insightly and so far, am impressed.

It can understandably make you feel overwhelmed to try to ramp up project planning and how it fits into managing a bunch of marketing tools, to-do lists, collaboration and activities, especially when using some of the tools or doing certain activities are also new to you. It was how I felt when I first reviewed project planning software options and then tried to understand how to use them. I could have quit and kept limping along with the nagging knowledge of how much better things would be if I were more organized. I finally determined mastering this process was not something I could afford to put off. If I did that, I would never learn how to manage everything I needed and wanted to get done for my business. I found the way to make software useful to me is to use it to the point where I know how it works and then to keep using it, so I do not forget what I already learned. You have come this far in reading this book, which indicates you are serious about using the advice it contains to help your career. Don't stymie everything you have learned by balking at getting your chosen project management tool under your control.

Rather than going on project overload, which can cause discouragement leading to failure before you begin to get results, it might be best to work on a soft launch with a minimum number of tools deployed. Maybe it is a family picnic, or some other small get together with friends and family. Work on

learning to use the software and on getting your blast emails, postcards, and so forth on the schedule so you can ease into going full tilt on bigger, more meaningful projects. As your comfort level with the concept and using all the tools increases, with time and use, you will begin to find moving on to tasks that are more complex is less intimidating. I realize some of you may want to jump in and get everything spinning at once, and I cannot stop you. However, if you take your time and understand this is career changing, and that it never happens quickly, then it might help you resist biting off more than you can chew to start. That said, you should still have a balance where you also push yourself to make whatever your initial plans are both challenging and doable.

To begin, start from the date you want the planned activity to be available to the public, and work backward from there to find your estimated start date. For example, if I want a mailing to drop on June 1, I need to have it to the printer by May 1. That means I need to start designing it by April 1, and thus likely need to begin developing the concept by March 1. Somewhere in that three-month period, you may need to hire a graphic designer, have a copywriter review your work, find and hire a direct mailing service and a printer. Then you can decide if you will be offering special promotions to coincide with the event. You need to think through what specials or deals you will offer. You also will need to purchase or rent a mailing list, or arrange a trade of mailing lists with an appropriate partner. Just within that one goal, you can see, there are many moving parts. For you to have multiple goals with many steps that need to be completed going on at different times, you have to coordinate your efforts. Many of the activities listed above may be new to you. Give yourself adequate time to familiarize yourself and complete them. Once you have a particular activity under your belt, your next time doing these things will go faster and easier. This is how, over time, you can build a well-oiled synergistic guerrilla marketing machine that runs on time and gets more and more done.

With some items being used multiple times, in a list including blog posts, guest blog posts, social media mentions, public-

ity, email blasts, postcards, personal appearances, press releases, advertising, and more, you easily could have 16 - 20 different marketing activities coming together to create a synergy of touches for your targeted event. This can all take place within a two or three month window. By synchronizing your marketing, you are ensuring it gets you the maximum exposure for each kind of activity you use. The only way to organize and manage such an undertaking is to be vigilant in reviewing and maintaining your schedule. Your success will require that you use a systematized approach. There is a lot to manage with project goals, even starting with a twice a year plan. Do not be concerned if you decide to begin with fewer events while you learn and get better at it.

You must target your marketing so you can tailor your plans to a specific audience, and then make sure you stay in touch with those people throughout the year. Just staying in touch is nearly pointless. Your marketing efforts need to have a focus to them. Of course, you hope someone will pick up the phone, or go to your website and place an order after exposure to one of your marketing efforts. However, you also want them to be motivated to do something else. This could be to attend your event; come to your site to learn about a special offer or a new line of images; take part in a survey; recommend new buyers; or help you celebrate some career milestone.

To sell anything you need to have the aforementioned "touches." You would not think that companies like McDonald's and Coke, icons in their industries, would need to market their products. Besides making consistent products their customers like to consume, they have grown to iconic status precisely because they know the value of "reaching" consumers. They understand the importance of using marketing to consistently remind customers why they need their products. You can do the same thing. You can emulate these companies on a much smaller scale and obtain similar results. "Touching" a person six, 10, or even more times with messages delivered via social media, postcards, email blasts, publicity, blog posts, guest blog posts, press releases, referrals, and affiliate marketing is how you create awareness of you and your art. Any one of these marketing tools on their own would not create much of an im-

pact, but together they create a synergy that can genuinely start moving the dial on sales of your art.

The better you execute your plans, the easier it is for you to complete them more efficiently and with less stress. Remember to implement your time management skills and focus on your production management. Get enough sleep, schedule some recreation time, or just relax and enjoy some time with your family. As you tie all your ideas together, you will begin to see better results than you ever achieved by trying this and trying that, with no direction. Gone are the days when you would distribute an email to your entire mailing list, with no clear purpose and no way to follow up on it and expect results.

Commit to engaging in marketing activities only when they fit together in a greater overall plan. One that will help you generate awareness for you and your work. That will drive interest and then desire in your art, and finally, compel your best prospects and collectors to take action and order directly from you, from your galleries, or from your website and blog.

Final Words of Wisdom

Becoming successful as an entrepreneur is a daunting task in any small business, and is certainly true for visual artists and fine art photographers, if not more so. The number of things you need to juggle to keep things running can easily be overwhelming if you let it happen. Following my suggestions and advice here will minimize that outcome and maximize the other happy end of the spectrum in the form of a growing successful career.

For many years, I felt anxiety because I wanted to work on more books, blog posts, and workshops and develop help aids and training guides for artists. I would have loved to do so without having to do all the sales, marketing and tech work to make my business go, but I couldn't due to other obligations, including working to provide quality health care for my family. As such, like many reading this book, I juggled a demanding full-time job and a demanding next career gig. I tell you this, so you realize I totally understand how it would be a glorious life

for you as an artist to spend your time creating your work while your work magically sells, or if an angel somehow came into your life and managed everything on the business side for you. Like you, I learned to push the fantasies aside to concentrate on furthering my plans for my career.

Build Your Customer Base

Drat the luck, we are stuck rowing our own boats. The point of this book is to help you find ways to sell directly to a growing base of customers. While I am sure most reading this book will not be able to follow all the suggestions, I believe it offers you enough different ways to build a loyal following. I trust in doing so that you will free yourself from being dependent on others to sell your work. Should this happen, you will have happily put yourself in direct ongoing control of your career.

I believe in grabbing the easiest sales opportunities first. Yes, the Internet makes us all neighbors to a degree. However, there is nothing like shaking someone's hand, smiling at them and creating a bond that duplicating in an online experience is near impossible. As a society in a "We Cycle," we are moving towards the need for genuineness, authenticity, integrity and honesty. It is so much easier to communicate these traits in person than it is in an online environment. If you work on building a base of collectors in concentric circles around where you live, you can build a successful and lasting business. One that finds you are selling virtually all the art you are ready to let go.

The Case for Local Marketing

If you concentrate first on local marketing and networking within your community, you will form that base of collectors who are most likely to be your best supporters, referrers and repeat buyers. People like to buy from people they like. They wish to be proud of their talented hometown neighbors, or even from people within their state, region, or country. Whether a politician, an artist or an athlete gaining prominence, it is human nature to show pride that person is from your town,

state or your part of the world. You should use this dynamic to help you grow your business. While this theory and philosophy cannot work 100 percent of the time, it will apply more often than not to the artists who read this book.

Digital Marketing Is a Wonderful Tool – in Perspective

By the nature of how things work, digital online marketing lends itself to a global marketplace, but it also lends itself just as much to the local market. You do not dine, or shop or buy cars hundreds or thousands of miles from your home. If someone can buy art locally, get to know the artist, have the art personally delivered, and possibly get help hanging it, don't you agree it is likely that would be their first choice? By combining your direct local marketing and networking with your online marketing, you create a powerful guerrilla marketing mix that will meet and exceed your career aspirations.

Use digital marketing and social media for the useful tools they are. Just keep in mind they are not a magic potion replacement for traditional marketing.

Guerrilla Marketing for Artists Builds Bulletproof Careers

Learn how to use guerrilla marketing techniques to build your collector/dealer/gallery base. Guerrillas never fight wars. Instead, they focus on winning one small strategic victory after another. As you string those victories together, you become stronger, more capable and competent. Your ultimate success is when the enthusiasm and support of your growing base of patrons, fans and friends elevate your art career to the point where it will thrive in any economy.

Take what you learn here and get started moving your career to where you want it to be. Start small enough that you can handle the activities and avoid burnout or discouragement from feeling overwhelmed. This process is not a race. If you are

committed to making it as a successful full-time, or part-time artist, then accept it will take time to achieve your goals.

Congratulations! You have finished reading this book. Now, you can start working on implementing the ideas and actions outlined in the book. If you come away understanding how to implement the plans you have learned about, and are motivated to make them happen, then all the effort I have put into this book will have been worthwhile. Best wishes for a blessed, happy, prosperous, career.

Resources

Here is a list of the resources links and books found in the book. If you find omissions or corrections, please let me know for purposes of future updates. The lists are by no means inclusive as the amount of resources available for visual artists grows daily.

Go to this page for live links to these resources:

barneydavey.com/GuerrillaMarketingResources

Here is a shortcut: http://x.co/guerrilla

Books
- How to Profit from the Art Print Market, 2nd Edition- Barney Davey
- How to Price Digital Fine Art Prints - Barney Davey
- The Zen of Selling Art - Barney Davey
- "Starving" to Successful: The Fine Artist's Guide to Getting into Galleries - Jason Horejs
- How to Sell Art: A Systematic Approach to Creating Relationships with Collectors and Closing the Sale - Jason Horejs
- The E-Myth Revisited: Why Most Small Businesses Don't Work and What to Do About It - Michael Gerber
- The Tipping Point: How Little Things Can Make a Big Difference - Malcolm Gladwell
- The Art of Non-Conformity: Set Your Own Rules, Live the Life You Want, and Change the World - Chris Guillebeau
- The $100 Startup: Reinvent the Way You Make a Living, Do What You Love, and Create a New Future - Chris Guillebeau

RESOURCES

- Getting to Yes: Negotiating Agreement Without Giving In - Roger Fisher, William L. Ury and Bruce Patton
- Bargaining for Advantage: Negotiation Strategies for Reasonable People 2nd Edition - G. Richard Shell
- Getting Things Done: The Art of Stress-Free Productivity - David Allen
- Crush It - Gary Vaynerchuk
- The Thank You Economy - Gary Vaynerchuk
- Cracking Creativity: The Secrets of Creative Genius - Michael Michalko
- Ultimate Guide to Google AdWords: How to Access 100 Million People in 10 Minutes - Perry Marshall
- Power & Influence: The Body Language of Power - (YouTube video) http://x.co/zCzw - Deborah Gruenwald
- How to Become a Corporate Art Consultant - Barbara Markoff
- How to Be a Press Friendly Artist - Tara Reed

Blogging Platforms
- Blogspot - www.blogspot.com
- Squarespace - www.squarespace.com
- Tumblr - www.tumbrl.com
- Typepad - www.typepad.com
- WordPress - www.wordpress.com

- Blogging RSS Feed Services
- Feedburner - www.feedburner.com
- Feedblitz - www.feedblitz.com

- Brainstorming
- Mindmeister – www.mindmeister.com
- The Brain - www.thebrain.com

Copywriting Services

- Gramlee – www.gramlee.com
- Grammarly – www.grammarly.com

Direct Mail
- InfoUsa – www.infousa.com
- Experian - www.experian.com/small-business/direct-mailing-lists.jsp

E-commerce
- 3dCart – www.3dcart.com
- Open Cart – www.opencart.com
- Volusion – www.volusions.com
- OS Commerce – www.oscommerce.com
- Zen Cart – www.zen-cart.com
- WordPress E-commerce
- Woo Commerce – www.woothems.com/woocommerce
- Marketplace theme -premium.wpmudev.org
- WP e-store - www.tipsandtricks-hq.com

Email Marketing
- Madmimi.com
- Mail Chimp
- Campaigner
- Aweber
- iContact
- Constant Contact

Freelancer sites
- Guru.com
- Odesk.com
- eLance.com

Online Galleries
- Fine Art America – www. fineartamerica.com
- Artist Rising – www.artistrising.com
- Saatchi Online. www.saatchionline.com

- ArtSpan – www.artspan.com
- Xanadu Gallery
 - xanadugallery.com/Studios/Join.asp

Online Tools
- Free Map Tools – www.freemaptools.com
- Pixlr.com – www.pixlr.com
- Gimp photo management – www.gimp.org
- Wet Canvas Internet Sales Strategies forum – http://x.co/zDEh

SEO Tools
- Google Analytics – analytics.google.comGoogle
- Google Adwords – adwords.google.com
- Google Webmaster Tools
- – google.com/webmaster/tools
- Google Webmaster Tools Starter Guide - http://x.co/zCJm
- Google Webmaster Central Cheat Sheet for Family and Friends - http://x.co/zCKU
- Open Site Explorer - opensiteexplorer.org
- SEOMoz - seomoz.org/learn-seo
- SEO Tacklebox - seotacklebox.com/seo-guide.html

Time Management / CRM / and Project & Inventory Management
- Michael Hyatt My Ideal Week spreadsheet - http://michaelhyatt.com/more-margin.html
- ArtSala.com – art inventory tracker
- Todoist.com
- Insightly.com

Art Business Blogs Worth Reading
- artbizcoach.com
- artbusiness.com
- artsbusinessinstitute.org/category/blog
- artprintissues.com

- artistcareertraining.com/act-art-marketing-blog
- artsyshark.com
- faso.com/art-marketing-newsletter
- finearttips.com
- makingamark.blogspot.com
- painterskeys.com
- reddotblog.com
- theabundantartist.com/blog

About the Author

Barney Davey is the president and founder of Bold Star Communications. It is a marketing communications and consulting firm with an emphasis on art marketing. Since 1988, Barney has been intimately involved in the art business, as a sales and marketing executive for *Decor* magazine and its sister division Decor Expo trade shows. Over the decades, Barney has personally consulted with hundreds of the industry's top-selling independent artists, photographers and art publishers regarding their art marketing and advertising strategies. Through his blogs, books, workshops and consulting, he has helped thousands of visual artists improve the business side of their art career.

In addition to his art marketing consulting, he does public speaking, conducts webinar and in-person workshops on art and Internet marketing. He is the author and publisher *of How to Profit in the Art Print Market 2nd Edition, How to Sell Art to Interior Designers, The Zen of Selling Art,* and *How to Price Digital Fine Art Prints.* He also publishes the highly trafficked and well-regarded www.ArtPrintIssues.com, which is a business blog for visual artists and photographers. It has had more than 500 art business and art marketing posts published on the site since its inception in 2005.

Learn: barneydavey.com
Read: artbusinessblog.com
Subscribe: http://x.co/barney

Made in the USA
San Bernardino, CA
05 May 2015